"Masterpiece" Studies

The Pennsylvania State University Press
University Park, Pennsylvania

"*Masterpiece*" *Studies*

Manet, Zola,
Van Gogh,
&
Monet

Kermit Swiler Champa

Library of Congress Cataloging-in-Publication Data

Champa, Kermit Swiler.
 Masterpiece studies: Manet, Zola, Van Gogh, and Monet / Kermit
Swiler Champa.

 p. cm.
 Includes bibliographical references and index.
 ISBN 0-271-01088-6
 1. Painting, French. 2. Painting, Modern—19th century—France.
3. Painters—France—Psychology. 4. Modernism (Art)—France.
I. Title.
ND547.C366 1994
759.4′09′034—dc20 93-3547
 CIP

Published by The Pennsylvania State University Press,
Barbara Building, Suite C, University Park, PA 16802-1003

It is the policy of The Pennsylvania State University Press to use acid-free
paper for the first printing of all clothbound books. Publications on uncoated
stock satisfy the minimum requirements of American National Standard for
Information Sciences—Permanence of Paper for Printed Library Materials,
ANSI Z39.48–1984.

Contents

For Jody

Acknowledgments

First drafted in the summer and early fall of 1991, this book and the critical perspective it presents have been gestating (or perhaps fermenting) for well over a decade. The opportunity to write the book came largely by surprise. The author was unexpectedly cut off from research and travel options in western Europe and faced with a "why not do *that* book now" personal ultimatum. Preparations were partly in place thanks to research assistance in 1989 by Victoria Potts (graduate student in art history at Brown), and were supplemented by the similar efforts in 1991 of Michele Bloom (graduate student in comparative literature at Brown). Without their help my confidence in discussing later Monet and vintage Zola would simply not have existed.

Along with research assistance the author had the immeasurable good fortune of watching over and being inspired by Joanna Ziegler's purposefully interdisciplinary meanderings that eventually led to her splendid book, *Sculpture of Compassion* (Brepols, 1992). While her book and the present one appear superficially to have little in common, they have, in fact, everything in common. Both struggle to find some appropriate space of discourse in the confused ideological ambience of the history of art as it is currently practiced as an academic discipline.

The translations of the manuscript for the book and the crucial first editings were computer-executed by Judith Tolnick, the only person consistently willing and intellectually able to sort through my cryptic handwriting, my often muddled grammar, and my textual inconsistencies. Final drafts were patiently produced in several stages by Janice Prifty. Brown University graduate students in successive seminars read and critiqued various states of the manuscript. As always in my published work, I owe them debts too numerous to detail.

Philip Winsor of Penn State Press made the various stages from outside reading to final editing as smooth and effortless as possible. I am honored that he chose to become the book's text editor. His three most helpful readers were David Carrier, Michael Fried, and George Mauner. All of them, and they represent about as wide a range of methodological commitments as could be imagined, were exceptionally generous and helpful. Each provided extensive written reports that, taken together, were gratifying to contend with in late drafts of the book. Collectively, they have my eternal gratitude for their committed and sympathetic effort to help me make the book as convincing as possible. None tried to force anything; instead they pushed me ever more firmly in the direction I was already taking. One is infinitely blessed by such colleagues.

The only dark moment in the book's making came when Robert Motherwell died in midsummer, 1991. Over the last decade he had been one of my most enthusiastic readers. I had just finished the second chapter when I heard the radio report of his death. It was a very sad moment. How much I had wanted him to see *this* text; how much I had wanted to continue being challenged by *his* art.

Prologue

ost historians, I suspect, live obsessed by certain grand moments in the chronological terrain they routinely survey. Whether one is an historian of ideas, institutions, economic or political events, or works of art, there appear, the longer one studies, to be something like chronological power points, when forces of whatever sort seem simultaneously to collect and metamorphose. These points, in spite of their fascination (and possibly because of it), are what one waits longest to confront in order to interpret. Too much seems to be happening: the questions of where to begin and how to proceed are slow to form, and just as they form they slip away into a blur of new complexity. When history moves smoothly (or at least appears to) interpretive accounts can afford the leisure of special-interest probing, but when actions and events seem themselves to be what is interesting, the interpretive enterprise becomes almost terrifyingly subject to one or

another form of arbitrariness. The understandable temptation is to stay out of the interpretive game in order to avoid disclosing one's biases and intellectual inadequacies.

Speaking as an art historian dedicated to European and American modernism, particularly to its manifestations in painting, I freely confess to having avoided committing myself in writing to anything like an in-depth accounting of the two decades in European painting (and French painting in particular) that seem to stand virtually alone as the power points of pictorial modernism. Those decades are more or less clearly marked as 1880–1890 and as 1900–1910, with a few years of slippage backward and forward in each instance. The reader of the book that follows must not expect that I have managed at this time the confidence to confront 1900–1910. However, 1880–1890 seems to have come, if only vaguely, within my interpretive striking distance. It is not that I feel I am providing a full account of the unit of time that contains virtually the entire careers of Vincent Van Gogh and Georges Seurat, the blossoming of Paul Gauguin and the radical midcareer machinations of Claude Monet. What I *am* doing is offering a strategy for seeing all of the eccentric aesthetic activity that emerges in the 1880s as a single, if complex, field of pictorial and theoretical discourse, rather than a series or a progression of isolated events. Here, chronology per se does not interest me in an absolute sense. Random continuities *and* random discontinuities seem to me to crisscross chronology, providing patterns that are not sequential in any normal sense.

My guides through these studies have been the considerable numbers of persistently exciting paintings from the 1880s that I have studied firsthand on repeated occasions over the past thirty years. Between those visits there has been much time for musing over memories, for discussing the paintings privately and publically, and for reading what other scholars have written

about them, either singularly or collectively. My views of many of the canonized or "major" works have changed in most instances, but not in all.

In 1987 I used a substantial part of a sabbatical leave from teaching duties to reread systematically the greater portion of the published contemporary criticism of the period and, as well, to review the first historians of nineteenth-century painting that included significant treatment of the painting of the 1880s. The results of my reading were generally frustrating, as I found the period criticism, which I loved rereading, to be incontestably hermetic. Virtually nothing surfaced over the course of my reading to inflect in any particularly notable way what I had come to know from maintaining strictly visual familiarity with the paintings themselves over an extended period of time. The early historians were more provocative, since they collected and presorted in various ways many of the terms that had developed a currency in 1880s critical discourse. The emphasis placed in the histories on the persistent elaboration of the perceived aesthetic conversations between "modern" painting and symphonic music encouraged me to attend first to the historical and ideological background of those conversations in earlier nineteenth-century French painting. The result of this attention was the text for my exhibition catalogue, *The Rise of Landscape Painting in France: Corot to Monet* (1991), written for the most part in 1989.

The *Rise* text elaborated very broadly on what had only been suggested, namely, the musical paradigm for painting, in my earlier *Studies in Early Impressionism* (1973), and then worked with by extended but unsystematic analogy in my *Mondrian Studies* (1982). In those books, as in my past scholarship generally, what now seems to me perhaps an excessively rigorous type of visual formalism was softened contextually only by hints of the existence of a musical submodel. However, the combination of formalist rigor and loose musical referencing in those books seems in retrospect to have been precocious more

by intention than plan. As an interpretive strategy it protected both studies from being read as "just formalist," or even worse, by current notions of scholarly correctness, wholly involved with art for art's sake. At least some notion of context was allowed to appear in the early *Studies* without being elaborated. It appeared because it intrinsically felt right when it did and in the ways it did.

For some readers of the *Rise*, the elaboration of the musical model has seemed forced because it looms so unexpectedly large in that text. I do not agree with this view, and I tend to see it as a reaction to the confident expression of the interpretively unfamiliar. The *Rise* offers what is, I feel, a clear and comparatively well documented (both by paintings and texts) argument for the suggestion that symphonic music was the contextual dominant for modern French painting after 1830. Those readers who remain troubled to greater or lesser degrees by the interpretive perspective deployed in the *Rise* will likely have more to be troubled about in the present book. The source of discomfort will be in part the same, because once again I assume that symphonic music is the preeminent context for the painted operations of the 1880s. Whether it is an agreeable contention or not, I continue to insist that the context that sustains the production of works of art and consequently the context that their appearance indexes is primarily aesthetic in character, and only secondarily social, political, or economic. Aesthetic context for me is the dominant locus for art history's social history. I confess this as my scholarly and critical ideology, and all my interpretive maneuverings derive from it or circle around it.

Aesthetic context is where the arts converse between and among themselves. In any historical period it is difficult if not impossible to reconstruct this context with any real confidence. Yet an attempt must be made using a combination of perceptual and written cues. My own relative security in approaching the aesthetic context of the 1880s in France has, as mentioned

above, been slow to develop, and it has not been aided very much by the contemporary critical record that so many of my colleagues rely on routinely. That record is often opaque, particularly since so much of it centers on the emergence of neo-impressionism and the figure of Georges Seurat. Response to Seurat's accomplishment is perhaps the most singularly prominent feature in serious criticism of the 1880s, and it has, by being referenced as it has been so frequently, tended to make of the decade a more or less exclusive platform for that which seemed clearly new ("neo").

My experiences of the pictorial practices of the 1880s have never been productively organized by the critical and historical accounts that feature either Seurat's new system or, alternatively, Van Gogh's complex biography. Either focus seems to me more a matter of documentary convenience than of interpretive fecundity. Seurat's system and Van Gogh's biography provide easy solutions to the problems of how to view the decade, but unless they are viewed as the "props by default" that they are, they cast only weakly informing aesthetic shadows beyond themselves. Seurat's system is especially problematic. As a collection of standing academic theory, more or less contemporary color science and psychology, and seemingly easy describability, it encourages its own featuring by any and all interpreters seeking historical forward movement of either a conventionally stylistic or social sort. But if one uses Seurat overmuch, the highly visible and often more challenging richness of other modes of pictorial practice happening around him become in various ways and to various degrees inaccessible. Something roughly similar is true with Van Gogh's self-described aesthetic persona as it appears in his letters. This persona, as compelling and sympathetic as it is, remains wildly idiosyncratic and often so exclusively self-indexing as to make anyone else either as artist or as person irreparably uninteresting.

The search for the schematic operations of aesthetic context

broadly conceived for the 1880s falters, in my judgment, when too much attention is paid exclusively or dialectically to Seurat and Van Gogh. My scholarly instinct in recent years has been to push both artists slightly aside, and to watch what comes forward both visually and theoretically to join them. To be sure, Manet's last paintings, Monet's confusing area of new experiments with repeated images, and Gauguin's self-identifying first steps become increasingly prominent and challenging in themselves when Seurat and Van Gogh are placed in partial reserve. The problem that arises, though, is how to view the altered perspective and additionally how to be at least partly certain that this altered perspective is revealing of anything, particularly anything about aesthetic context. In the process of justifying my perspective I have not taken my leads from texts of a conventionally documentary sort—or at least I had thought not until I recently realized that I had.

For the present book, I have given in to a temptation that has long been in place in my experiences of and my musings over the most prominent pictorial activities of the 1880s. As I shall elaborate in Chapters 1 and 2, the single written text that has dominated my career of experiencing and reexperiencing the painting of the 1880s—sometimes dictating, sometimes confusing or reflecting what I have seen and felt—has been Emile Zola's 1885 novel, *L'Oeuvre*. I'm hardly the first, nor will I likely be the last scholar, to be haunted by the novel, which seems to deploy so much about the making pains of modern painting, while doing so in such an authorially self-serving and unabashedly fictional way.

Why, one might very reasonably ask, do I choose to be led by what is a piece of fiction in my search for the elusive facts of aesthetic context? Why especially do I do this when there is so much in the way of so-called standard documentation waiting to be used? I trust that the confidence I achieve by referencing Zola, rather than other types of nonfictional documents, be-

comes understandable in the main text of the present book, but what I should say here is that the very transparency of this novel's unreliability is what makes me gravitate toward it. I feel that I know where and how (at times even why) Zola is being unreliable both for fictional or aesthetically self-aggrandizing reasons. I tend to be less attuned to the unreliability of other, seemingly more neutral, forms of documentation treating the same material.

Seen working as an artist of a particular sort, a realist novelist, Zola becomes to a comparatively seasoned reader a generally predictable liar as regards precise historical fact. He does not ever seem quite so predictable or quite such a liar with regard to his description of this beloved "milieu." The quality of rightness or "truth" that he pursued in his writing generally was based in getting the milieu laid out clearly so that the behavior of characters followed more or less inevitably from where they found themselves being who they were and doing what they did. In treating Zola's novel both as a fictional object and a quasi-reliable layout of aesthetic context, I am attempting to make deconstructed fiction produce broadly sketched but richly textured fact. Weaving a new art-historical fabric with Zola's textures, I derive the nearest account I can currently envision of aesthetic context as internally visible from the mid-1880s.

The contextual use I make of Zola's novel is admittedly unusual in the art-historical accounting of modern materials, in that it is largely inductive rather than deductive in character. I accept the topical in Zola and work largely with that, not chronologically but indexically. As regards models for my use of Zola, I find them, and only a few of them, in premodern scholarship. A considerable amount of the most creative historical and art-historical writing on the European Middle Ages and particularly the late Middle Ages attends (following leads from modern anthropology) to formulaic (or ritualized) documents, such things as vitae and monastic or quasi-monastic rules. Watching

for consistency and breaks in consistency from one formulaic text to another, certain aspects of the nonformulaic become isolated and then cross-referenceable in one way or another. If patterns emerge that are not the expected ones—those literally contained in the texts—the new patterns are seen to signal an opportunity for viewing something like suppressed historical reality, in the cracks rather than the main vessel of a text or group of texts. My viewing of Zola's *L'Oeuvre* in the present book works in an analogous, if not identical, fashion.

I am spending time describing my overarching reliance on Zola here rather than in the body of the text that follows largely because I want the reader prepared to anticipate quantitatively more attention to Zola's novel than to any single painting or group of paintings from the 1880s. At the risk of some exaggeration I feel that my reading of Zola has written my book for me, or at least the greater part of it. With my reading of Zola in charge of my writing, I am inclined to be highly selective in what I single out for strenuous visual description of a formalist sort. When the interpretive situation demands it, I introduce extended formal analysis, but the book is not padded with all such that I might easily muster. Readers familiar with my *Mondrian Studies* rather than my more recent scholarship will be especially surprised by the comparatively incidental employment of formal analysis. Having said this I realize that I have raised some basic questions regarding the cumulative authenticity, or at least the comparative reliability, of my scholarly practice.

How can two books by the same author be so different when both treat various aspects of canonical modernist painting? Is one better than the other? Is one right-headed and the other wrong? Or, are both relatively or totally capricious? I must ultimately rely on the opinions of informed readers to handle these questions. I can say only that for me, both books are right. What I mean is that I cannot imagine having written either differently than I have. I do not remember plotting the course of either book

methodologically in advance of the writing. I obviously felt when I wrote *Mondrian Studies* that the artist's paintings, being what they were and communicating themselves as they did, required sustained and elaborated formal description. Mondrian's paintings seemed then (and still seem) to be quite literally about formal adjustments and counteradjustments. They live in an ambience of endlessly interruptable and changeable motific simplicity. They are, therefore, interpretable within the largely fixed rules of what appears to be a very limited visual game, which becomes exciting only when the player's passion is critically intuited in brilliant move after brilliant move. In *Mondrian Studies* I followed the game as attentively as I could in the only terms that seemed interpretively honest or even relevant.

There were no such feelings in place regarding the aesthetic operations of the 1880s. In fact without Zola's guidance, there were no certain feelings at all. But as suggested above, accepting Zola's guidance was not a possible step for me until quite recently. I needed a great deal of help to develop any degree of confidence. Help came over the course of writing *The Rise of Landscape Painting in France: Corot to Monet,* where it no longer seemed useful to isolate myself as an interpreter from certain aspects of the most provocative historiographic and literary theories that emerged in the late 1970s and 1980s.

New forms of critical questioning were very much in the air, and more than a few of them figured in forming my critical operations in the *Rise.* In fact, so many of them were seen to figure (if only in very selective ways) that a not inconsiderable number of consistently conservative critics (some of them former scholarly fans of mine) thrashed me soundly in their reviews for what they perceived as my intellectual "front-sliding." This is apparently a much greater error than "back-sliding." Assuming, even demanding, my return to conventional formalist sanity, my most conservative critics have refused to grant that I might not just be academically trendy in the *Rise.* My truly

trendy colleagues, by contrast, find my *Rise* text, and the present one, insufficiently in step, a judgment, I suspect, colored in no small way by my having written for *The New Criterion*, and perhaps even worse, continuing to read it publically. Whatever the case, what I began to do in the *Rise*, namely, to chart aesthetic context, has denied me the comfort of secure scholarly classification. In the absence of such, I classify myself as neoconservative, a postformalist and an eclectic, which means that I am continuing to do what I have always done. I work with and from canonical pictorial achievement, but I do so in various ways, depending on what achievement I'm viewing and then interpreting. And I try to react responsibly rather than with too much apprehension to what is happening around me intellectually.

With the *Rise*, I began to look at the modernist aesthetic game from the outside. I did so because a fully formed inside game, such as Mondrian's, had not yet been invented or practiced. I continue from the outside in the present book, letting Zola direct me as to where I should stand. Another book has been in the wings as the present one took shape. It is tentatively entitled *Music Made Visible*, and it will include several essays written on topics related to the musical model for modernist painting that have appeared in various exhibition catalogues, with a new centerpiece essay examining the aesthetic context of the color music concerts of A. Wallace Rimington in England in 1896. I mention the incomplete book here simply to indicate that the sequence in my work that will appear over the next few years is not an absolutely clear index to the sequence of the works' generation.

Finally, let me offer some technical descriptions of what follows in this book. There is a rhetorical device that carries over from the *Rise*, namely, the provision at the beginning of several chapters of a group of quotations of various sorts. This grouping of quotations—in one instance a single long quotation—was established before the writing of each chapter as a sort of palette, or

in terms of Wagnerian opera, a leitmotif chart, that would provide an ambience for the various discussions that follow. These groupings were useful to me in the process of writing, and I hope they provide a comparable service to readers.

Also continuing from the *Rise*, but in a more carefully calculated form, is the periodic change of voice in the present text. In the *Rise*, the scholarly norm of third-person voice was employed throughout the main text. Then, in the extended "Methodological Notes," the voice changed to the first person. This seemed appropriate since the latter identified the author as a distinct advocate-commentator on his text. In the present book the scholarly exposition and the commentary tend to intermingle. Changes of voice identify one from the other as clearly as possible.

I take full authorial responsibility for the small number of illustrations: there are only four, and they are reproduced in black and white. They are intended only to orient or remind the reader about images central to the text as it proceeds. They are not intended to stand for, or to replace, the examination of the original images by the reader at whatever point such may be possible. In like manner, there is not a freestanding plot summary of Zola's *L'Oeuvre* provided. Different portions of the text are paraphrased as necessary for ongoing discussion, and by the end of Chapter 2 the reader has been given a fairly extensive glance at both the scope and detail of the novel. However, this glance is intended primarily to encourage the full reading of the Zola, something I believe every modernist should undertake routinely, and perhaps even enjoy!

Introduction

Contemporary public interest, insofar as it is in touch with the visual arts, seems nowadays to desire a return to specifically artistic questions. The reader no longer expects an art-historical book to give mere biographical anecdotes or a description of the circumstances of the time; he wants to be told something of those things which constitute the value and the essence of a work of art, and he reaches eagerly for new concepts—for the old words will no longer serve—and once again he is paying attention to aesthetics, which had been entirely shelved.

—*Heinrich Wölfflin,* Classic Art[1]

1. Heinrich Wölfflin, *Classic Art—An Introduction to the Italian Renaissance*, trans. Peter and Linda Murray (1st ed., 1898; London and New York, 1953), xi.

There is a conception of art history which sees nothing more in art than a "translation of life" (Taine) into pictorial terms, and which attempts to interpret every style as an expression of the prevailing mood of the age. Who would wish to deny that this is a fruitful way of looking at the matter? Yet it takes us only so far—as far, one might say, as the point at which art begins.

—*Heinrich Wölfflin*, Classic Art[2]

T he following four loosely interconnected essays were conceived and written slightly less than a century after the two Wölfflin quotes. Like Wölfflin, but far more humbly and far less skillfully, the present author undertakes to address by positive example some of the insecurities that have prevailed increasingly in art-historical writing after 1945 (rather than in 1895). The material isolated for analysis is not Wölfflin's beloved "classic" art of c. 1500 in Italy, but the most widely beloved historical art of the present day: the art of Manet, Monet, and Van Gogh. The popular celebrity of this art has far outpaced confident art-historical assessment of the sort that would permit it, in Wölfflin's terms, to remain art. Sociological, political, and psychological analyses, because of their presumed basis in solid written documentation, have increas-

2. Ibid., 287.

ingly come to dominate the study of what is arguably the most art-full of all moments in the history of Western painting: the period from the mid-1870s to the mid-1890s in France.

The sequence of discussion that appears in the text which follows is not so much chronological as topical. The time period studied is, generally speaking, the decade of the 1880s with some significant glances back into the recent past of the 1870s and forward to the future of the 1890s. The so-called symbolist movement of the later 1880s features prominently in all sections of the text, but its particular dynamics are never addressed directly. Instead there are four studies, three of painters and their painting, and one focusing on a novelist writing historical fiction who presents in certain, often peculiar ways, aesthetic issues that seem mysteriously absent from the more conventional documentation that surrounds the period. Chapter 1 discusses one painting by Edouard Manet, his *Bar at the Folies-Bergère* (his last great Salon painting); Chapter 2 treats Emile Zola's novel, *L'Oeuvre*, a treatment already begun in Chapter 1. Chapter 3 discusses a single image by Vincent Van Gogh that exists in a surprising number of "copies," and Chapter 4 is devoted to a broad overview of Claude Monet's "series" and "proto-series" practice.

Much emphasized as an interpretative base upon which each chapter is built is the musical paradigm for the most ambitious painting practice of the 1880s.[3] The reader of the present book needs to keep in mind the author's firm conviction that the aesthetic example of German concert music, first Haydn's, Mozart's, and Beethoven's, and later Wagner's, inspired, drove, and secured the aesthetic operations of modern French painting continuously, and from a very early point. The decade of the

3. Kermit S. Champa, *The Rise of Landscape Painting in France: Corot to Monet* (Manchester, N.H., and New York, 1991).

1880s, where this book centers, features in both its imaging practices *and* its critical discourse, what is perhaps the fullest flowering of the musical paradigm.

It is primarily via discussion of the musical paradigm that the present author brings into relief the sensuous side of 1880s painting practice—the side that, so to speak, contains the art. In order to manage this operation, a good deal of time is spent in various sections of the text critiquing various forms of sociohistorical scholarship that give only lip service to properly aesthetic issues of any sort. This brand of scholarship, which is currently dominant in academic discourse treating the 1870s and 1880s (as well as the formative impressionist decade of the 1860s), has many ideological subforms—Marxist, feminist, and Freudian—but *all* forms proceed from the activity of reading rather than looking. All will be viewed in the text that follows as deriving from the practice of iconology as first defined and then refined by Erwin Panofsky.

As a formalist (but hopefully not an "empty" one), the present author has basic problems with any critical or historical practice that features reading as the primary operation guiding the viewing of works of visual art. Those problems are dealt with when and as appropriate over the course of the present text. The book, as developed, was not intended primarily as a critique of what are seen as misguided critical perspectives fixed in recent art-historical scholarship, but that critique is a prominent subtext nonetheless.

Ideally, what the book manages is to provide model accounts that deviate from current academic norms, with the intention of being more to the point of what painting is about and of providing, at least schematically, some potential routings outward from a tradition of art and society discourse that has become dry and ideologically impacted from overuse and the absence of self-questioning.

With the firm belief that great works of art constitute a very

special category of work, more self-indexing than indexical of anything else, the present author risks being seen as a politically incorrect intellectual elitist. So be it. Certainly works of art are treated here as being an elite species, but not as an inaccessible one. Historical criticism has, one might argue, as its very highest mission, the production of interpretations that make that which is abnormally difficult by virtue of novelty accessible to those who are for whatever reason unable to interpret for themselves. I am certainly not the first quasi-socialist to suggest this. I shall have accomplished my "educational" task in this book, as in others before it, if I facilitate some meaningful visibility of aesthetically grand achievements without reducing the images addressed to some form of sociological or anthropological rubble.

None of the studies presented here has been published before in any form: they were handwritten in sequence with the plan of appearing exactly as they do here. This mode of production, too, goes against the current academic grain, but it produces something that is "original," judged by present scholarly standards, if not perhaps by considerably older ones.

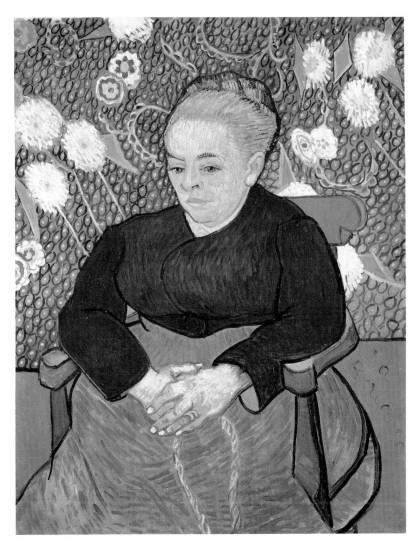

Vincent van Gogh, *"Lullaby"—Madame Augustine Roulin Rocking a Cradle* (*La Berceuse*). Courtesy Museum of Fine Arts, Boston. Bequest of John T. Spaulding

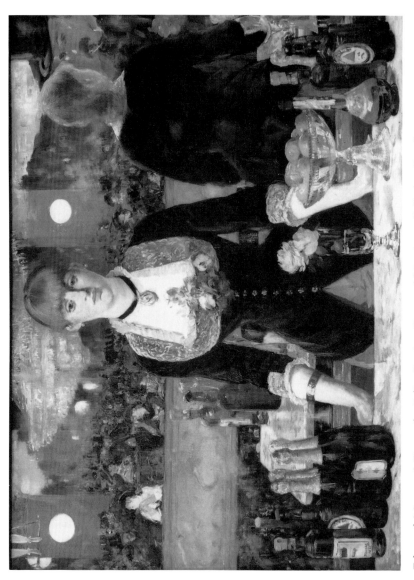

Edouard Manet, *A Bar at the Folies-Bergère*. Courtauld Institute Galleries, London

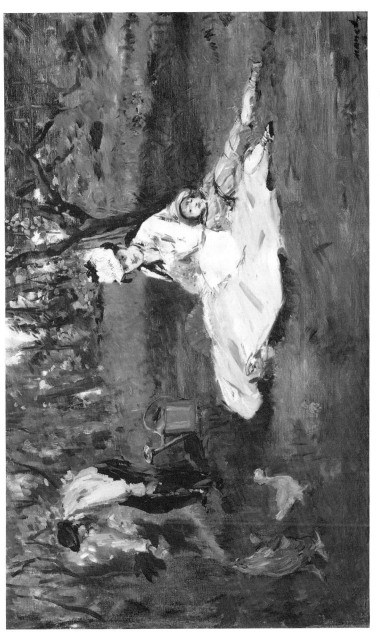

Edouard Manet, *The Monet Family in Their Garden*. The Metropolitan Museum of Art, New York. Bequest of Joan Whitney Payson, 1975

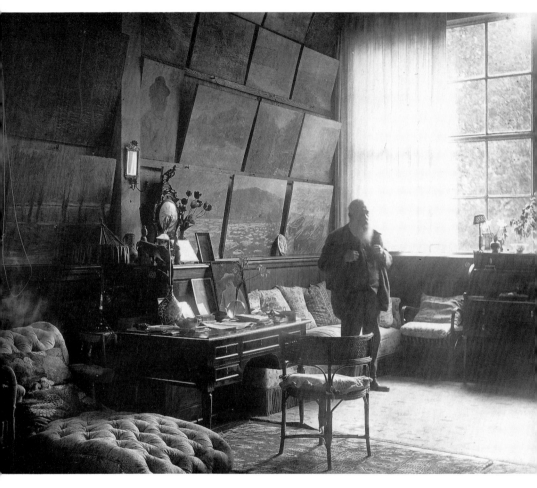

Claude Monet in his house at Giverny (photo: Roger-Viollet)

1

Le Chef d'Oeuvre (bien connu)

Just like the charming barmaid who must be bright, alert, and well disposed for fourteen hours a day, if she wishes to keep her place! How much better than being on the streets!
—*Bernard Shaw*[1]

Mehr untergeordneter Art und von einem gemischten Publicum besucht sind die Cafés-Chantants *und die* Spectacles-concerts, *die seit der Theater-Freiheit auch zuweilen Vaudevilles, Operetten, Possen etc. geben.*

1. Bernard Shaw, "The Dead Season," *Shaw's Music: The Complete Musical Criticism in Three Volumes*, ed. Dan H. Laurence (2d rev. ed.; London, 1981), 1:745–51, esp. 749.

. . . Das besuchteste und beste Local aehnlicher Art (halb
Theater, halb Café-chantant) sind die Folies–Bergère, *Rue*
Richer 32, in der Naehe des Boulevard Montmartre (Eintritt
2 fr.). Wer sich nicht in den Zuschauerraum setzen will,
promeniert in den letzteren umgebenden Raeumen, waeh-
rend auf der Buehne Jongleurs, Coupletsaenger etc. mit ihren
Vortraegen abwechseln. Die Gesellschaft is uebrigens sehr
gemischt.

—*Karl Baedeker,* Paris und seine Umgebungen[2]

Who could have painted what looked like an idol belong-
ing to some unknown religion? Who could have made her
of marble and gold and precious stones and shown the
mystic rose of her sex blooming between the precious col-
umns that were her thighs, beneath the sacred canopy that
was her belly? He had plunged into something beyond
reality.

His face was turned towards the picture and quite close to
the Woman whose sex blossomed as a mystic rose, as if his
soul had passed into her with his last dying breath, and he
was still gazing on her with his fixed and lifeless eyes.

—*Emile Zola,* L'Oeuvre[3]

2. (Leipzig, 1878), 58–59.
3. [The masterpiece], trans. Thomas Walton (Ann Arbor, Mich., 1968), 351 and 356.

A Bar at the Folies-Bergère *is certainly the most phantas-magorical work ever painted by Manet. Out of his mastery of the play of light he devised an unreal setting for the barmaid who is his central figure. She is shown standing, directly facing the spectator, but there is nothing static about her. The ornaments, the bottles, the flowers in the vase suffice to give her a phantomlike appearance. And this effect is infinitely increased by the mirror behind her, in which we see that she is talking to a customer and see also the crowd sitting at tables in the bar—all of this scarcely hinted at, as in a daydream. No painter before or since Manet has trans-posed reality into such a phantasmagoria of lights. This girl's image is magical precisely because she is a phantom among phantoms, with a grace that is extremely attractive.*
—Lionello Venturi, Impressionists and Symbolists[4]

*I*n attempting to move from the experience of visual "speechlessness" before Manet's great image to the exercise of verbal interpretation, one feels oneself in quicksand. The move should not be made too rapidly since the image is immensely rich in the sensations—both nameable

4. Trans. Francis Steegmuller (New York, 1950), 24 and 25.

and unnameable—that it provides. Like any true enigma the painting stubbornly remains most coherent on its own terms. It becomes increasingly impenetrable and incoherent in direct proportion to the a-perceptual distance (or interpolated context) that is brought forward to account for the inherent density of the picture's own visual proclamations. As Manet's last "masterpiece" (and probably known in process as likely to be so) the *Bar* manages to encourage and then seemingly to frustrate every attempt to decode systematically its only half-articulate sensory signage. But how many attempts there have been at decoding!—some comparatively straightforward and many more ideologically convoluted. Each assumes to posit something like an ultimate solution. But of what?[5]

What are the barriers to definitive interpretation posed by the *Bar* and how are they posed? And are they really any different from those posed by Courbet's *Atelier*, earlier Manets, or any number of Vermeers, Watteaus, or Corots? Genre paintings—particularly complex figural ones—have from a comparatively early date flaunted (or at least toyed with) textual ambiguity by the very act of withholding resolved narration. Without closure (or even clear opening) the nonnarrative figure painting *as text* contributes, whenever it is presented, a double option to would-be critics: take it or leave it *or* insist on unities of narratively devious sorts. Art historians, like historians, are never very comfortable with the first option because it leaves them (God forbid!) potentially inarticulate. Thus the second option invariably prevails to encourage critical excursions of, at times, almost inconceivable complexity, when judged against the object (the painting) that presumably initiates them. The weap-

5. For the most recent review of the literature, see David Carrier, "Art History in the Mirror Stage: Interpreting *Un Bar aux Folies Bergère*," *History and Theory: Studies in the Philosophy of History* 29, no. 3 (1990): 297–319.

onry of those attached to the second option are the more or less generically unspecified "written" texts usually referred to as *documents* and deployable as evidence. Ideally the discourse in the second option involves several historians or critics agreeing on the rules of the game for the meaning (hence the use) of certain species of documents. These can be termed consensus documents. This agreement makes discussion (agreement and contradiction) possible within the game, whether or not the game is an interesting or even a useful one. Obviously, without agreement there is no game and no critical discourse, but the simple existence of discourse in no sense guarantees relevance to the object/subject (or painting, in the present instance) from which agreed-term (and document) discourse presumably derives. At a certain point in any critical discourse ostensible subject and ostensible interpretative strategy seem almost naturally to reverse roles, with the latter finally displacing the former almost completely as the locus of inquiry. To say this in 1993 is perhaps simply to utter a truism, but sometimes truisms need repeating.

The entire process of second option interpretation seems inevitable simply because of the way any historically based inquiry develops. Whether admitting it or not, practitioners of historical interpretation (and I include myself among them) identify documents (or written evidence) and deploy them in such a way as to have them—the documents—say what it is wanted for them to say and in the way that it is wanted to be said. But we must accept that interpretative solutions, which presumably are what are proposed, are only comprehensible (acceptable or not) in the discursive ambience of consensus documents. As David Carrier has pointed out in so many different ways, the incompatibility of different discursive ambiences—the lack of unanimity on what to call facts/documents and the ideological underpinnings of the "callings"—virtually eliminates the possibility of productively comparable routings of interpretations and the cross-referencing

of interpretations, once interpretations of whatever sort become truly self-referential.[6]

All of this makes the task of entering a "new" interpretation of a painting as ideologically mauled as Manet's *Bar* somewhat thankless. One may choose one position—an essentially primitive formalist position—as a modified option. Who, then, who has thought or written from a more or less Marxist, more or less semiotically and psychoanalytically sophisticated social history perspective, whether Robert Herbert's, Theodore Reff's, or T. J. Clark's type, has any vested interest (or even curiosity) in reading what is offered?[7] To assume that the painting itself ought to be reconsulted "straight," so to speak, runs against the entire grain of what is currently seen as academically mandatory (and politically correct) contextualization. Pre-iconographical inspection wasn't given much in the way of intellectual time-credit by the institutionally dominant iconologists of the 1950s and 1960s. It is given even less by politically accented (in various ways) social historians writing after the mid-1970s.

The problem with proceeding from the first option (take it or leave it) is that it appears to be prima facie unintelligent, or to be more devastating, illiterate. But is it? Klaus Herding, who is himself no stranger to contextual analysis, had some hesitations regarding Clark's *The Painting of Modern Life* (1985), a book in which several major Manet paintings, including the *Bar*, are discussed at great length.[8] Writing in a not unfavorable review published in 1987, Herding nonetheless proposed a few bother-

6. Ibid., and David Carrier, *Principles of Art History Writing* (University Park, Pa., 1991). The present essay is deeply influenced by Carrier's brilliantly irritating interpretations of art-historical interpretation.

7. Robert L. Herbert, *Impressionism: Art, Leisure, and Parisian Society* (New Haven, 1988); Theodore Reff, *Manet and Modern Paris* (exhibition catalogue) (Washington, D.C., 1982); and T. J. Clark, *The Painting of Modern Life: Paris in the Art of Manet and His Followers* (New York, 1985).

8. Klaus Herding, review of T. J. Clark's *Painting of Modern Life,* trans. John William Gabriel, *October* 37 (Summer 1986): 113–25.

some warnings regarding the direction of Manet studies—a direction that after 1977 was in essence first dictated, then driven, by Clark. "It would seem more reasonable to postpone the inquiry into historical links until the actual visual facts of a painting prove impervious to direct analysis or pose a dilemma that only background information can solve." Later in his review, Herding goes even farther by suggesting that "the attempt to read deep significance into the most minuscule of visual signs, that is, to imply a conscious intention on the artist's part, may well strike some as a relic of the rationalist thinking that was so widespread during the late 1960s" (122 and 123). Without rejecting the intellectual attractions of Clark-type second-option social history interpretation (or for that matter pre-Clarkian iconology as practiced on Manet) Herding is simply pointing to something like the "discourse as subject" problem posited above. Largely because of Herding one is encouraged to reenter Manet studies generally, and discussions of the *Bar* in particular, with art prominently in view.

There are in fact a fair number of immediately pre-Clark interpretive perspectives to be reconsidered, perspectives proceeding *from* rather than *aiming at* painting. That the most important of these were simply left out of Clark's book (even left out of its seemingly exhaustive bibliography) is reason in itself to recognize them here, if only in brief. Working with what Clark "leaves out" provides both a useful and fascinating exercise, particularly because the *textes refusés* (or *textes maudits*) tend to be (as Herding has noted) written in German by Germans or to have been produced chronologically between 1968 and 1972, in English, presumably the gestative years of Clark's intellectual/ideological birth (or rebirth?).[9] Robert J. Niess, Michael Fried,

9. Robert J. Niess, *Zola, Cézanne, and Manet* (Ann Arbor, Mich., 1968); Michael Fried, "Manet's Sources," *Artforum* 7, no. 7 (March 1969): 28ff. (special issue); Mark Roskill, *Van Gogh, Gauguin, and the Impressionist Circle* (Greenwich, Conn., 1970); and Kermit Swiler Champa, *Studies in Early Impressionism* (New Haven, 1973).

Mark Roskill, and the present author all advanced one or another form of Manet interpretation in this period. Not all focused on Manet alone, but each in one way or another presented either a scheme of priorities or a model of looking/reading that assumed the primacy of Manet's objects (paintings) as subjects. Fried's 1969 study "Manet's Sources," of course, is absolutely exemplary in this regard.

What Fried offered was a closely argued view that what resided in the artist's constant employment of quotations (from past art) in the first half of the 1860s had an inner consistency that tracked, consciously or not, the mid-nineteenth-century art-historical debates regarding national artistic character. In Manet's instance, as Fried saw it, the issue of Frenchness was the primary locus for pictorial borrowings (or quotations) followed rapidly by the addressing of issues of artistic internationalism. Fried set in relief what were, in Manet, operations of intense artistic self-consciousness. The combinations of formal quotations identified by Fried often became in his analysis highly speculative and at times so seemingly farfetched as to open his entire discussion to the suspicion of massive overinterpretation. Yet detail aside, Fried's study (which is long overdue for republication) ought to have been taken more seriously than it was, if for no other reason than its intelligence. But, following Reff's irritated review, only Anne Hanson and Françoise Cachin continued to make routine gestures toward recognizing the existence of Fried's work.[10] In the writings of the former, Fried's positions were unfortunately often misrepresented (at least in part) and in the work of the latter the above-mentioned "suspicion" remains in force underneath a veneer of respect.

10. Theodore Reff, "On Manet's Sources," *Artforum* 8, no. 1 (September 1969): 40–48. For differing views, see Anne Coffin Hanson, *Manet and the Modern Tradition* (New Haven and London, 1977); and Françoise Cachin, Charles S. Moffett, and Michel Merlot, *Manet 1832–1883* (New York, 1983).

Lamentably, Fried did not undertake to discuss the later work of Manet. His interest was in the artist's primary aesthetic strategy. By implication Fried's interpretation of this strategy can be seen to cast certain forward shadows, but these have not been pursued; largely, one suspects, because of the ascendence of the new academic social history model of interpretative correctness in the decade after Fried's study appeared. Had Fried laid some clearer claim to all of Manet, his work would have been harder to marginalize, but he did not.

Unlike Fried, Roskill and, finally, Werner Hofmann were primarily concerned with the artistic situation of the 1870s and early 1880s when they undertook in the 1970s to interpret the aesthetic and theoretical components of that situation. Needless to say, Manet's work figured more or less strongly in their quite different interpretive perspectives. Roskill offered the notion of a sort of calculated style-merger to account for the seemingly hybrid character of Manet's behavior in his last masterpiece, the *Bar*. The painting is seen by Roskill as a sort of *summa* combining (even superimposing) aspects of quintessential 1860s Manet with equally quintessential 1870s alternatives of both a technical and imagistic sort (*Van Gogh,* 230). Hofmann was more interested in the development, elaboration and metamorphosis of Manet's "mythic" females—the last of whom, of course, is the Folies barmaid.[11]

While it would be difficult to argue the proposition in much depth, there are enough elements in common within the Fried–Roskill–Hofmann discourse to make that discourse appear, if not actually (overtly) conversive, at least potentially so. To begin with, all three writers seem to want in some way or other to keep paintings *in full view* as they discuss them. They *need* the paintings in order that what is said about them finds a home that can be revisited by the reader/spectator. Collectively their inter-

11. *Nana: Mythos und Wirklichkeit* (Cologne, 1973).

pretations undertake to amplify a visually perceived stimulus or series of stimuli. That this amplification proceeds art historically in Fried, in terms of style dialectics in Roskill, and in a sort of image-association fashion in Hofmann is beside the point. In each instance image or images initiate and to a degree control interpretation even while that interpretation branches outward into various forms of personalized contexting.

Fried, Roskill, and Hofmann are hardly left in a wordless void of discourse as they pursue what I would term extended first-option forms of interpretation. In fact they seem to have found nearly as much to discuss, standing (figuratively speaking) in front of their pictures as have their social history colleagues working with their backs turned and in rapt contemplation of their socio-political notes. Herding seems to have been right in suggesting that the reach beyond the picture for interpretation before the picture exhausts itself as a visually declarative structure risks being located beside the point, so to speak, rather than being even remotely on the nose.

Axiomatically expressed, but hardly uncontroversially so, it would appear that for the benefit of the production of genuinely conversant discourse—in the absence of absolutely fixed common terms, definitions, and perspectives—interpretations (of whatever sort) ought ideally to require the primary existence *and* the continuous referenceability of the object interpreted in order even to be termed interpretations. When this is not the case the "discourse as subject" phenomenon is imminent. Perhaps what has been differentiated in the above, as first- or second-option interpretation, ought to be abandoned in favor of more relative distinctions that insist of the second option only that accountability to the ostensible subject/object be strenuously maintained. No particular form of contexting ought to be privileged in principle so long as the elaboration of context (however that is conceived) is irrevocably linked to the precise object under scrutiny—an object whose particularity precludes

being replaced by any other one more or less "like" it. Some (but certainly not all) social history written over the last two decades is in fact responsible to the standard of referenceability in much the same way one expects of contextual study that is not overtly sociopolitical in prospect. In some rare instances (usually in Herbert's or Clark's own work rather than in that of their followers) it has been even more than just responsible.

So much for what has been a preliminary exercise in positioning the interpretation of the *Bar* that eventually follows in this study. Let us begin approaching the painting (without ever forgetting it) by introducing the interpreter clearly in order to give the *Bar* in advance the necessary means for its own defense. Some manner of authorial autobiography is probably appropriate at this point, even though like all such presentations, it is likely laden with much bad memory and a considerable amount of more or less clever and convenient retrospective invention.

I (the present author) have spent extended periods of time looking at the *Bar* in various geographical locations—first in London in 1963 and in 1968, then in New York in 1983 (where it was hung much too high), and in Chicago in 1987. My Chicago viewing, besides being the most recent, was also the most extended, lasting on and off over two days. I have been fairly diligent over the years keeping up with the ongoing bibliography of the painting, but never until the last six months working to review that bibliography with the intention of producing a study of my own. Obviously I had much of Venturi, John Rewald, and Fritz Novotny in my head in 1963.[12] By 1968 when my attention was primarily focused on impressionist landscape painting of the 1860s, I was probably more primed

12. Venturi, *Impressionists and Symbolists*; Fritz Novotny, *Painting and Sculpture in Europe, 1780–1880* (Baltimore, 1960); and John Rewald, *The History of Impressionism* (1946; 3d rev. ed.; New York, 1961).

with Zola (*L'Oeuvre*) and Jules Laforgue; in addition, my then senior colleague at Yale, Robert Herbert, had caused me (thereby engaging my perennial resentment) to read some Walter Benjamin.[13] In 1981, I had produced with my graduate students an ambitious exhibition with a catalogue, *Edouard Manet and the Execution of Maximilian* (Providence, R.I., 1981), and probably had the primary and secondary bibliography on Manet more at my mental fingertips than at any previous or subsequent point. In 1987 I was just beginning my more or less total immersion in visual and written materials that I believed argued for the notion of a master model, resident in the French reception of German symphonic music, for a good deal of what transpired in post-1830 French landscape and (to a lesser degree) figure painting. This notion formed the critical substance of my *Rise of Landscape Painting in France: Corot to Monet* (1991). In retrospect, I realize (or perhaps just imagine) that my study of the *Bar* in Chicago in 1987 focused to a large degree my treatment at least of Manet's painting in the *Rise*. Whatever the case, I grant the painting in recent years a sort of personal "muse" status.

Like other moderately privileged academic subsuperstars, I've done a great deal of undergraduate and graduate teaching of late nineteenth-century material over twenty-five years, but in all honesty I can't remember what profundities or foolishness I uttered in the classroom regarding the *Bar* until fairly recently. After 1988, though, I'm aware of giving more lecture attention to the picture for what I assume were new reasons in new contexts and, perhaps more to the point, joining the extra attention to the required reading of Zola's *L'Oeuvre*. Why I began to couple an emphasis on the *Bar* and *L'Oeuvre* so persistently after

13. Jules LaForgue, *Selected Writings of Jules LaForgue*, ed. and trans. William Jay Smith (New York, 1956); Walter Benjamin, *Illuminations*, with Introduction by Hannah Arendt, ed. and trans. Harry Zohn (New York, 1968).

1987 I can't recall, and I'm not sure which—the painting or the book—led when it did to the partnering of the other. Again, prodding my unreliable memory, I think I read *L'Oeuvre* first in 1962, then not again until 1980. I know I read it first (along with three other Zola novels) to prepare for my Ph.D. exams. I don't know why I reread it in 1980, but I'm glad I did, because I remembered the broad outlines of the book well enough in 1987 to want to look at it again to follow Zola's complex handling of the activities of painting, music-listening, and writing. Four months ago, in preparation for this study, I read *L'Oeuvre* a fourth time and reread as well Niess's compendious study of the novel, published in 1968 under the title *Zola, Cézanne, and Manet* (Ann Arbor, 1968).

None of the foregoing "autobiography" would be especially germane to the present study were it not that in the fall of 1987 something about the *Bar* began to obsess me while I was in London (and where the painting temporarily wasn't). I had been invited to lecture on the Courtauld Collection traveling exhibition during its stopover in Chicago. I prepared my lecture in the Courtauld Institute Library and then flew off for my two days in Chicago. As already suggested, I was in 1987 interested intellectually in essentially one thing: my evolving musical master model. That interest and that the *Bar* was to a greater or lesser extent the prime object in the Courtauld Collection combined to emphasize certain "facts" about the painting (or surrounding the painting) which, while not exactly new to me, began to take on an accelerated life. Douglas Cooper's *The Courtauld Collection* (London, 1954) and Cachin's Manet Retrospective catalogue entry of 1983 (*Manet 1832–1883* [New York, 1983], 482) on the *Bar* reminded me that the first truly substantive act of critical appreciation of the painting (excluding relatively predictable reviews, postmortems, etc.) was Emmanuel Chabrier's purchase of the painting from the estate auction of 1884 at a *very* considerable price.

The painting's first owner, Manet's longtime friend who was alone in attendance when the artist died, was a *composer* of music; not only a generic practitioner, but one of the leading lights among the younger *French* Wagnerists, as opposed to the Franck-inspired Wagnerists who happened to be French (like Vincent d'Indy). Why, I wondered (and still do), did Chabrier want the *Bar* in order to hang it over his piano in his studio? As a collector of impressionist pictures Chabrier might have bought any number of works at the estate auction for better prices, but he clearly had his mind set on the *Bar*. Looking through the Cooper catalogue and the rather hastily assembled traveling catalogue of 1987 by John House, I discovered that the *Bar* was in one very important respect not unique in Samuel Courtauld's collection.[14] Another masterpiece, Gauguin's *Nevermore*, was also from a composer's collection, this time Frederick Delius's. As with Chabrier and Manet there seems to have been at least a brief period of personal contact between Delius and Gauguin in the mid-1890s. Courtauld, then, chose to own two composers' choice pictures by two of his favorite nineteenth-century painters. Was this sheer coincidence, or were the *Bar* and *Nevermore* privileged by association as preeminently "musical" paintings by Courtauld (or perhaps by his eminent friend, the critic Roger Fry)?[15] The question is intriguing, but it is not answerable in any definitive way. What can be said is that "preeminently musical" would have been uniquely high praise for any painting cited in critical discourse in England from Pater through Fry. Moreover, the Courtauld family was investing culturally in more than just painting in the 1920s. Mrs. Courtauld personally covered financial deficits for

14. John House, Dennis Farr, Robert Bruce-Gardner, Gerry Hedley, and Caroline Villers, *Impressionist and Post-Impressionist Masterpieces: The Courtauld Collection* (New Haven, 1987).

15. Roger Fry, *Vision and Design* (rpt.; New York, and Scarborough, Ontario, 1956), esp. "Essay in Aesthetics," 16–38; Champa, *Rise*, 58–59.

the Covent Garden Opera during several of its most fragile years and founded (and endowed) the Courtauld–Sargent "popular" symphonic concerts in 1929.[16]

What I have so far deployed as autobiography is a rough record of my visitations to the *Bar*, coupled with suggestions of what likely controlled or inflected my seeing at one or another time. To this day, I have never approached the painting disinterestedly—not that I haven't tried, I just haven't succeeded. I had always been reading before I looked, and that reading to a considerable degree conditioned (if not absolutely, at least partly) what I saw and the order in which I saw it. The most persistent leitmotif in my reading-conditioned looking has certainly been Zola's *L'Oeuvre*. It was in my head before I ever saw the picture (as opposed to reproductions of the picture) and it remains there after I last saw the picture. All of this suggests that for some reason, or combination of reasons, possibly related exclusively to the way my particular critical thinking happens, looking at the *Bar* has always involved mentally referencing *L'Oeuvre* consciously or subconsciously. It is an uninterceptible part of my experience of the painting; strangely, it doesn't seem to be so for any other scholar, at least to the same degree.

It is not unusual in any sense to see in the bibliography on Manet one or another scholar "leaning" on Zola. In fact one can anticipate, at least schematically, the direction of many interpretations by many authors simply by noting which Zola novels (along with Zola's criticism) a given scholar references. Looking at random, one notices Herbert using *Thérèse Raquin*, *L'Assomoir*, *Nana*, and *La Curée*. Clark uses *L'Assomoir* and *Nana*; Hanson uses *Nana*. Cachin in her discussion of the *Bar* uses *La Ventre de Paris* extensively. But anything—even a glance in the direction of *L'Oeuvre*—is hard to find. Moving away

16. Cooper, *Courtauld*, 4.

from strictly Manet interpretation, the situation changes considerably; Rewald and Sven Loevgren (among others) base a good deal of their account of the art-political situation of the early 1880s on both the existence and reception of this novel.[17]

I am not particularly interested here in following out the Rewald–Loevgren reading of *L'Oeuvre*. What I am interested in doing is sorting as best I can my fixation on the mirroring that I feel between the painting and the book. I know that I thought I was seeing "the Masterpiece"—that unnamed allegory of the city of Paris and its life focused in the figure of a beautiful woman—the first time I walked into the old Courtauld galleries and saw the *Bar*. To what degree I expected or prepared myself for this experience I cannot possibly judge, but there were enough things materially "wrong" about the feeling that I have to believe the painting filled in many of the gaps by itself, and that I just reacted to the filling instead of the gaps. Once I saw that the painting could be, as an image presence, what it clearly wasn't as a literal subject (as Zola had described it in the frustrated workings of his chief painter-character Claude Lantier), I could never put the experience away. From 1963 on the painting was, for me at least, most about what it wasn't about. Zola's novel gave an account of what it wasn't about, but it left just enough fictional space for "what it was about" to blossom in its own real space outside the novel.

Zola himself was, I suspect, able to envision the details of failure surrounding Claude Lantier's picture at least in part *because* he had confronted its opposite in the *Bar*. That is why so much of his fictional history oscillates between his authorial imaginings about the *Bar* and about its failed opposite. The timing of the completion of the picture and the novel is impor-

17. Rewald, *History*, 534 and 543. Sven Loevgren, *The Genesis of Modernism: Seurat, Gauguin, Van Gogh, and French Symbolism in the 1880's* (rev. ed.; Bloomington, Ind., and London, 1971), 40–50. I shall be presenting very shortly an essay on Zola's *L'Oeuvre* and its status as an art-historical text.

tant to note in this regard. As in the case of Manet's *Nana* and Zola's book with the same title, the completed painting came first but after the written plan for the novel. The rather different situation that obtains around the *Bar* and *L'Oeuvre* is that Manet died in the middle of the sequence. The effect of Manet's death on Zola, coupled with that of Wagner in the same year (1883), is difficult to measure, but whatever that effect, Zola did not begin *L'Oeuvre* until 1885, well after his elusive written "appreciation" of Manet in the catalogue for the latter's commemorative exhibition at the Ecole des Beaux-Arts in 1884. While there is some uncertainty regarding the precise degree of personal closeness between Manet and Zola in the decade before Manet's death, there seems little doubt of Zola's emotional reinvolvement in the years right after—the years that culminated in the publication of *L'Oeuvre*.

One of the dominant thematic currents in Zola's novel is a kind of fear/fascination with the problem of artistic impotence. Claude Lantier is only one of a host of impotent artists in Zola's text, where both the sexual and aesthetic connotations of the term "impotence" are perpetually toyed with. The most frontal form of impotence is the inability to create (to finish) anything important at all. The qualified form is described in terms of artists who cannot regenerate the power of their celebrated early work. Much has been written regarding Zola's displacing into the various characters of *L'Oeuvre* his own free-floating self-doubt regarding the questions of potency and "living up to early promise." Most critics seem to feel that Zola (as an artist) works himself into several artists practicing different media in *L'Oeuvre*, while at the same time posing fictively as the "novelist" Sandoz and of course standing as the inventor of the actual novel's text as well.

The novel purports to take place (in a realist fashion) in the years between about 1862 and the early 1880s, with the plot built around advanced painting, as it first appeared at the Salon

des Refusés of 1863, as it gradually lost its way, and then collapsed completely. Advanced fiction, Zola's realism, tracked advanced painting without seeming so overtly to lose its way; yet at the end of the novel, realist fiction too is suspected of never having overthrown the burden of romanticism—in other words to have failed even while persisting. What has thrived persistently in Zola's fictional account? Seemingly only music (Schumann and Wagner), but Zola's one artist-character, Gagnière, who becomes absorbed with music, loses his grip on his own medium, namely, painting. Women (of various sorts) float through the novel, being both necessary to the practice of art, yet—like music—operating as a powerful and dangerous distraction or intoxicant. To the bitter end of the novel, real woman as model and painted woman as art (more real than real), contest one another for "control" of artists (always male in Zola's text). *Liebestod* between the real woman, the painted woman, and the artist replaces a conventional Pygmalion and Galatea terminus to the novel.

What has all this to do with the *Bar*? Arguably a great deal. With the *Bar* complete (as with Wagner and *Parsifal*) Manet died potent, with his aesthetic boots on and still shining. Throughout *L'Oeuvre*, Zola rhapsodizes in a variety of ways over the bliss of an artist's death at full power—before full or partial impotence, as fact or just fear, are experienced. The alternative is positively purgatorial. It is an existence, endured half as reality, half as mortal dread by Sandoz and Bongrand (the older-generation modern painter-character) in *L'Oeuvre*'s final lines.

Zola had tracked Manet and Wagner throughout his mature life. In Aix along with Cézanne he had been a member of a local Wagner society. In Paris, he rapidly bonded artistically with Manet, and in spite of "social" differences (perhaps even jealousies on Zola's part) he kept a close, self-calibrating eye on

the painter until the latter's death. In the early 1880s Zola certainly knew, as everybody who was anybody did, that the twin pillars of modern art, Manet and Wagner, were physically infirm, although neither was truly "old." Miraculously, though, both artists mustered the strength and the will to produce a masterpiece that rounded out an old series of masterpieces—a final masterpiece as fresh if not fresher than the first. This is exactly what Zola's Claude Lantier could not do! Why? Because he had a sort of unspecified genetic (?) weakness that drove him in directions opposed to those which he might successfully manage artistically. In their late years Manet and Wagner, too, had their share of potentially self-frustrating impulses. With the music-drama finished, Wagner fancied himself doing symphonies (presumably nine) while Manet had begun as early as 1879 to propose (for the Paris Hôtel-de-Ville interior) vast allegorical "decorations."[18] He seems even to have envisioned going back to religious subjects and doing a *Crucifixion*. Fortunately, death intervened in both instances to prevent either artist from acting on what were very likely aesthetically unsound notions.

But Zola remained alive for a considerable time and in being alive certainly knew right along that he might not be so lucky; so he seems to have undertaken *L'Oeuvre* to displace his fear through the invention of a complex fictional situation in which the threatening accomplishment of the *Bar* was prevented from taking place. He constructed an ambience of failure, using many of the details of a more or less plausible historical context (probably more of them than in any "straight" historical record)—a context not unlike the one that had produced a

18. Hanson, *Manet*, 129. For Wagner, see Cosima Wagner, *Cosima Wagner's Diaries*, 2 vols., ed. and annotated by Martin Gregor-Dellin and Dietrich Mack, and trans. Geoffrey Skelton (New York, 1977). Odd but persistent mentions in vol. 2 after 1879.

masterpiece in the *Bar*. Working, one suspects, at least in part to preserve his own sanity, Zola fictionally destroyed Manet's masterpiece accomplishment by denying it and then by replacing it with his view of his old friend Cézanne's failure to achieve clear aesthetic direction. Significantly, he called his novel, *L'Oeuvre* (the work) and not *Le Chef-d'Oeuvre* (the masterpiece)—even though English translations thoughtlessly translate the title as the latter. He risked in his title (and in the novel itself) simply producing "work." *L'Oeuvre* was not Zola's literary masterpiece, even though it begins as though it were going to be. More important than literary quality was the elaborated activity of denial, denial of the fact that the great pictorial realist, Manet, had managed the gloriously elusive, and perhaps for Zola, ultimately the impossible: the late, arguably even the definitive, masterpiece.

While it would no doubt be a wild exaggeration to suggest that Manet's accomplishment in the *Bar* literally and totally programmed *L'Oeuvre*, the sheer aesthetic willfulness and power of the painting was certainly not lost on Zola, and the author's reaction in his novel remains a very personal, if potentially very informative, one. But of what is it informative? Clearly Zola was in some way reactive to the "conjuring" as opposed to "recording" activity of ambitious modern painting *and* modern realist writing. In the context of *L'Oeuvre*, however, he seems systematically intent on portraying painting's conjuring as being more dangerously uncontrollable than writing's. He faults Claude Lantier's work for its lack of discipline, direction, and consistency of method. For Zola, the lack of all this virtually guarantees the impossibility of producing work of genius. With much system of work in his own writing, Zola had become increasingly discontent with (or perhaps threatened by) the continuing tendency he noted in the painting of Manet and his impressionist friends to work in a sort of one-picture-at-a-time

fashion, rather than proceeding toward the consolidation of a "great" modern style.[19]

Rereading any of Zola's criticism after the mid-1870s, one wonders, though, what Zola would have recognized as pictorially "great" style if he had seen it. Manet's production of the singular, late masterpiece of the *Bar* might have been read by Zola in either of two ways, and he seems in *L'Oeuvre* to have conflated them. Either he was unable to accept the achievement of modern style that Manet's work posited so powerfully, or he simply didn't understand it (or want to). As perturbing as the accomplished last masterpiece must have been—and as enviable—there remained for Zola always a sense of uncertain premises and a sort of randomness that gave to all Manet's masterpiece achievements the appearance of "luck." Lucky conjuring could not produce great modern style in Zola's terms or, if it could, his own work, which proceeded very much as style in the everyday sense of the term, might not be what he thought it was—namely, modern.

Zola's problems with Manet have, in many respects, much in common with those of a considerable number of late twentieth-century Manet scholars. A fundamental unwillingness to accept the lack of any nonaesthetic program or social "higher" functioning of critical intelligence (which in many respects defines Manet's practice quite well) initiates the discomforts of interested witnesses experiencing Manet nearly a century apart. Like Zola, contemporary scholars of the socially sensitive sort force themselves to interpret Manet in ways that make of what he doesn't do the implied true meaning of what he does. This line of critical reasoning easily posits system in nonsystem, a consciousness of social tensions in the refusal to picture them, and a range of populist sensitivities encoded in the "conscious exclusion" of clear signs of such.

19. Hanson, *Manet*, 26–27.

What one encounters persistently in recent scholarship is an absolute refusal to permit idiosyncratically original modern painting to be what it seems, preeminently in Manet's instance, to be, namely, original in ways stamped with unmistakable signs of individuality. The performance of originality, even in Richard Shiff's terms, the calculated fashioning of the pictorial terms of originality, are not left to be self-indexing.[20] The terms must (in order to be worthy of the powerful effects achieved) encode more than self, and obviously the more politically radical, the better. Aesthetic and social radicalism must go hand in hand, mustn't they? If they do not, what excuse could possibly be managed to justify the interest in (the liking and respect for) radical painting by politically radical spectators? Human nature, being what it is, hates the prospect of friction between the forms of loved experience and loved ethical "values." The embrace of some species of anarchism or mysticism seems the only manner of psychological ventilation available if and when this *Ur*-friction becomes unbearable and undeniable. Significantly, the decade that contained the appearance first of the *Bar* and then of *L'Oeuvre* (rather like the decade of the 1980s) was marked by a persistently increasing number of intellectual defections in the direction of one or another species of anarchism and mysticism. The privileging of the irrational and unnameable and the psychologically troubled leads, almost inevitably (or so it seems in retrospect) to Freud's psychoanalysis of human behavior and the theosophists' complex models of the great order of being.

Such facile intellectual pronouncements aside, upon returning to the *Bar*, one is ultimately confronted by the fact that what one stares at is and remains preeminently a painting by Manet— one that only he could or would have devised, and that could or

20. Richard Shiff, *Cézanne and the End of Impressionism: A Study of the Theory, Technique, and Critical Evaluation of Modern Art* (Chicago, 1984). See especially "Part Two: The Technique of Originality," 55–154.

would never have been devised as it is without twenty years of the artist's own painting standing in the background and cheering it on. To experience the painting is to experience Manet's private art history: to watch what has been done first to muster, and then dispense, something thoroughly unique. Fried's argument that Manet's art simultaneously discovered and identified itself through complex processes of quotation is at once reaffirmed in the *Bar* and at the same time inevitably mutated. The aesthetic momentum that Manet had to develop through borrowing from past art in the early 1860s now resides in the richness of his own twenty-year achievement as a painter, and in his experience of the work of his contemporaries. Replacing the spectator-provoking operations of his painting of the early 1860s, and his broadened pictorial treatment of the 1870s, there is in the *Bar* something totally unique—not classifiable simply as a style merger, but rather more like what Venturi was reacting to when he called the painting "phantasmagorical."[21] This is not a term Venturi or anyone else would be likely to apply to any other of Manet's works. Yes, there are plenty of puzzling ghost/shadow parts of certain paintings beginning with the *Absinthe Drinker* (Copenhagen, Ny Carlsberg Glypotek) and continuing through the Poe illustrations and the *Portrait of Faure as Hamlet* (Essen, Museum Folkwang and Hamburg, Kunsthalle), but none of these truly anticipates the comprehensive "phantasmagoria" that Venturi found the *Bar* to be.

Probably the closest Manet ever came to a "phantasmagoria" (as defined in narrow realist terms) was in his 1864 *Dead Christ with Angels* (New York, Metropolitan Museum of Art) where he painted a quasi-conventional *Dead Christ* in an indistinct sepulchral setting with attendant angels. Although obviously posed by models, and clearly demonstrated as having been so in the literal and publicly (contemporary) offensive "bodiness"

21. See note 4 above.

of the main figure, Manet's painting nonetheless proceeded as a pictorialized enactment of a religious fiction. The demonstrative fictionality of Manet's imaging in this picture (including angels) is far stranger than that which would appear in the following year's *Jesus Mocked by the Soldiers* (Chicago, Art Institute) where *tableau-vivant* elements are more consistently in place. Mysteriousness would continue on and off in Manet's post-1860 work—narrative ambiguities, spatial oddities, etc.—but mystery as "phantasmagoria" vanishes *only* to reappear in the *Bar*.

What else of "Manet" reappears in the *Bar*? Principally there is the recurrence of his tendency to build an ambitious painting around a female figure. Clothed, unclothed, or costumed female figures in more or less consistently legible ambiences are a constant in Manet's early imaging practice (not that there are no males) and they continue to be so right into the early 1880s. Sometimes the women are portraits, but more often they are something like character-icons, ranging from the unmistakable prostitute in the *Olympia* (Paris, Musée d'Orsay) or the *Nana* (Hamburg, Kunsthalle) to the independent (and more or less self-explanatory) woman of the *Déjeuner sur l'herbe* (Paris, Musée d'Orsay), the *Woman with a Parrot* (New York, Metropolitan Museum of Art), *The Balcony* (Paris, Musée d'Orsay), *Le Repos* (Providence, Museum of Art, Rhode Island School of Design), the *Gare St.-Lazare* (Washington, National Gallery of Art), and *The Plum* (Washington, National Gallery of Art), to mention only a few well-known works. While it is possible to problematize these images at will and more or less indefinitely through various strategies of interpretative enterprise, none (except perhaps the *Déjeuner*) seems really to *demand* much complicated "reading."

Appearances, while often somewhat surprising in various ways, are (at least after the *Déjeuner*) never effortfully confusing. Instead the various female figures seem to serve as familiar

and interesting imaging pegs for Manet to hang his paintings on, and pretty much the same could be said for his male figures. Whatever their gender, Manet's figures tend to be motific and readable as such. Their development is, however, always stunningly original in pictorial terms. At base, figures are Manet's way of seizing his viewer's attention rapidly, at times frontally using spectator-contacting gaze, at other times both frontally and laterally to introduce a kind of perpendicular pictorial counterpoint, but one that always refuses either to narrate, or to indent the picture surface spatially in any abrupt or complicated fashion. A fictive pictorial immediacy is what Manet seems to want, and what he usually gets. In addition, the narratively thin character of that immediacy serves rapidly and very consistently to establish Manet's images as "paintings"—as original Manets.

Figures (whether male or female) specifically guide the virtuoso paint construction that is a Manet. Different figures call up different forms of construction. Repetition (or any particularity of continuous or developing style) is avoided by the quirky painting-to-painting differences of figural presentation and avoidance of anything truly typical in terms of technique. The technical components of Manet's craft are reasonably continuous after 1866, but the order and proportion of the deployment of expressive effect (whether in color, paint structure, or drawing) is highly unpredictable. Zola was right in observing the absence of clear and conclusive system (or style) in Manet, but he was wrong to see it as an aesthetic limitation. It is, in fact, Manet's refusal of self-limiting style that makes him always so open to the moment of particular pictures, and so able to act on his intuitions of the moment. This is where the "modern" in Manet resided, and it made him routinely able to make expressive content develop through his technique rather than to be imprisoned by it.

Until very late in his life Zola was quite willingly imprisoned in his technique, feeling all the while extremely virtuous (at least

on the surface) about having devised it.[22] How, one wonders in retrospect, could he have granted Manet the respect his achievement in "unstyled" modernity obviously merited? Obviously he couldn't, any more than can many Manet scholars writing today. The intellectual self-annihilation stakes are just too high! How much safer it is to persist in thinking of everything as contextually determined text (filling in missing words as necessary) than to grant Manet his sublimely inconsistent and changeable intuitions and his genius in converting them into painted masterpieces.

It would be absurd to say that the *Bar* is, as a motif, anything but Parisian and in some manner an image of modern life. But this argument ought to follow rather than lead to an engagement with what is first and foremost a major, major Manet painting. To use a well-worn, but still marginally fashionable term, it is the undeniable "presentness" of the *Bar* that marks it off, like so many of Manet's works, as thoroughly distinctive things in themselves, as objects more free than not, willed into being by a very particular individual in ways very particular to that individual and no other. Manet, the individual in this instance, was a person of immense artistic culture. He was this before, during, and after being a charming *flâneur* of indeterminate political leanings. His culture causes Paris to vibrate in the *Bar*, and as noted above, it is a culture first inherited and then powerfully inflected with a succession of masterworks.

Wiping aside thoughts of Zola's *L'Oeuvre* (an admittedly impossible task for the present writer) it is amazing how fresh, immediate, and even natural the *Bar* is at first sight. That all of this derives from Manet's imaging and technical fictions is beside the point. Equally beside the point are all of the "gaps" that

22. Grange Wooley, *Richard Wagner et le Symbolisme français: Les rapports principaux entre le wagnérisme et l'évolution de l'idée symboliste* (Paris, 1931). See 154–56 for a discussion of Zola's late "conversion" to Wagnerist/symbolist practices.

appear when the painting is materially dissected as painted illusion. Like all of Manet's best works, the *Bar* looks right before it looks wrong, and the latter sensation never completely subverts the former.

Part of the painting's seeming naturalness (as opposed to its realism) comes from the "knowing" viewer's sense of its breeding. The scene is familiar as a monumental variant of a considerable group of Manet's paintings of bar, restaurant, and *café-chantant* images beginning with the lithograph *At the Café* (1869) and continuing through the *ébauche* for the *Bar* (the Netherlands, Private Collection). The inclusion of mirrors (or other reflective surfaces) and the image-dominating female figure are familiar features of paintings both within this group from the 1870s and outside it (*Le Repos* and the *Gare St.-Lazare*, for example). The unfolding of this group of works has been discussed many times, most recently by Herbert, so there is no need to review the situation here, except to remark that the "serving" woman becomes increasingly prominent in the *café-chantant* images after 1875.[23] A major exception is the weirdly conceived *Le Bouchon* (Leningrad, Hermitage) of c. 1878 where two male figures are superimposed in an exercise of radical foreshortening in the center of the image, so that at first glance they seem one.

What else is familiar in the *Bar*'s barmaid is the all-dominating presence of the centrally positioned figure. She is the *modern* art-historical motif within the picture, recalling, besides several of Manet's 1860s women, one by his partner in scandal at the Salon des Refusés, Whistler's *White Girl* (Washington, National Gallery). And Whistler hangs in the background in other ways as well. Mirrors and reflections figure more prominently in his work of the late 1850s and early 1860s than in that of any other advanced realist. The most significant instances occur in *At the Piano* (Cincinnati, Taft Museum), c. 1859; *The Music Room*

23. Herbert, *Impressionism*, 59–92.

(Washington, Freer Gallery), 1860; and *Little White Girl* (London, Tate Gallery), 1864. In the last of these Ingres's use of a mirror in his well-known *Comtesse d' Haussonville* (New York, Frick Collection), is quoted overtly, but made to function in reverse.

Mirrors and image-dominating women were obviously a substantial element in whatever Manet remembered of the early 1860s, but the former were positioned just outside his work. They were Whistler's. In the 1870s mirrors increasingly became Manet's (and to a lesser degree Degas's). What was precisely Manet's in the 1860s, besides the simple frequency of image-dominating women, that is brought forward (and reinforced by her incontestably hieratic position) in the *Bar* exists in the barmaid's pose, which unmistakably repeats that of the head and torso of the *Dead Christ*.

In spite of the art-historical "breeding" of the barmaid figure, it doesn't look like a quotation; it looks like a nicely dressed, redheaded barmaid, set semiplausibly at her working station—a station whose magnificence is magnified by the apparent vastness and opulence of the space over which she presides—the space in *front* of her, known to the spectator via the mirror. There are, of course, many problems with the reflected space if one questions it visually, as many have. Suffice it to say here that proportions, positions, and distances (perspectives) are sheer chaos to describe, if one assumes that such description is necessary or even desirable.

The most fascinating elements of the chaos occur up close, in the mirror's most forward reflection. Here one sees (a) the absence of the reflection of the artist-spectator; (b) the repetition without scale reduction of the still-life elements on the bar; and (c) the appearance, on the right, of the barmaid, reflected from the rear and addressing an otherwise unaccounted for, therefore doubly troubling, "client." There is a fictive/fictive spectator implied, but no fictive/real one. Finally, there is another prob-

lem generated by the mirror, one having to do with the fictive function of the bar itself.

How does the barmaid-customer transaction work, and what is it about? It has often been remarked that the ale, cognac, champagne, and liquor bottles are unopened.[24] Less attention has been paid to the absence of glasses to serve anything in. There are none on the bar or, judging from the unreliable mirror, none underneath or behind it. What is there for anyone, barmaid or customer, to do, besides gaze? Manet gives no answer, and in refusing to do so literally snares his spectator into a condition of something like inarticulate visual babbling.

If the painting weren't so sensuously beautiful continuously from edge to edge, the spectator would, one suspects, cry rather loudly for help disentangling herself from a nightmare—Venturi's "phantasmagoria." What I am obviously suggesting (or at least it is obvious to me) is that Manet reduces the spectator of the *Bar* to the condition of being a supplicant before his great canvas! When mirrors lie and bars can't serve, what kind of spectacle is being offered? The answer is ultimately simple: the spectacle of painting as painting, an answer implied if not developed most recently by Cachin (*Manet*). She, virtually alone among contemporary commentators, seems to find the painting quite soothing overall.

By setting his whole image against a continuous mirror (of a seemingly conventional rather than Lacanian sort) Manet employs what is perhaps the oldest paradigm for painted representation, only to have it self-deconstruct before the spectator's eyes. He adds to this the newest technology of "illumination"; namely, bright, unfiltered electric light (or at least the newly familiar appearances engendered by such). Electric light passes into Manet's representation via emphatic white-brightness, the emphasis on high values of hues, and the lightening of grays.

24. See, for example, Cachin, *Manet,* 482.

His medium is drier than ever (approaching pastel) and it accepts a great deal of last-minute gray/white overpainting and accenting. Pictorially the effect of all the lightness and the comprehensive dryness of surface is to make the painting more frescolike than any other painting Manet ever produced. Perhaps he was thinking in advance about Hôtel-de-Ville mural possibilities, perhaps not. In any event the *Bar* holds and amplifies the wall like no other large-scale, imagistically concentrated figure painting produced after Velázquez's *Surrender at Breda* (Madrid, Prado).

From a strictly pictorial point of view, the *Bar*, having gloriously problematized legibility, proceeds to become the penultimate ellision between representation, "painting" sensation, and finally decoration. Its unity, which is, needless to say, of a very particular and precarious sort, results from Manet's intuitive surefootedness in what is a magnificently complex tour de force of technique. He painted many pictures more materially sensuous, but never one so complexly delectable, while at the same time so troubling.

The iconographic and psychological teasings, the discontinuous positionings of legibility, are as exciting and as precarious as the pictorial ones. Abandoning my earlier contention that, for me at least, the *Bar* had for many years solved itself imagistically by being the reverse of Zola's fictional (and failed) *Allegory of the City of Paris*, and now entering, with some dread, a second "fin de siècle," I am starting to sense more or less conventional religious vibrations as well. I interpret these as deriving from Manet's image in some way without being exactly certain how.

What are we to make of Manet's picturing of a young, sexually attractive, fashionably dressed redhead, positioned in priestly manner tending a bar, that is obviously not a bar in the normal sense? In fact, as Manet arranges it, it's much more like an altar. Arguably symbolic flowers emerge from the vase on the bar and

from the barmaid's bodice. Her potions (ointments?) are more or less symmetrically positioned to her left and right. As *we* see her, she is not what she is seen in the mirror as being (we see only her back, or figuratively, her past). Perhaps the she we see is repentent—a Magdalen rather than the prostitute most scholars would have her be. Perhaps she is there to heal us, the socially and spiritually disoriented urban bourgeois spectators and Manet, the physically failing artist. Perhaps, too, he has *passed into* her (which is why we don't see him or ourselves in the mirror), so that he and she are both healers possessed of different potions or lotions but with equivalent powers and promises (or at least comparable degrees of compassion).

With all these "perhapses" in place, what might we have in the *Bar*? Paris (Modern Life), Manet, and La Madeleine as a complex sociopsychological and aesthetic unity—a unity that first irritates and then soothes. I think Matisse would have understood what I am suggesting. He, too, moved with his own image (or without it) through a maze of models, mirrors, and modern feelings.[25]

25. Carrier, *Principles*, 219–36.

2

Zola's *L'Oeuvre*

Its Status as an Art-Historical Text

(Wie es eigentlich gewesen ist?)

*T*n 1946 John Rewald published the first edition of his *History of Impressionism* (New York). The book has, of course, been revised and updated many times since, and it continues to stand as an enduring example of a highly influential sort of art-historical accounting. Without fear of exaggerating, one may say that the history of impressionism (or the writing of it) has never been the same since the appearance of Rewald's study. The thirty years prior to the appearance of the book contained relatively little in the way of modern scholarship attending to a movement that had been, in both the

museums and the marketplace, largely superseded. The great early historians—Théodore Duret,[1] Richard Muther,[2] Camille Mauclair,[3] Julius Meier-Graefe,[4] André Fontainas and Louis Vauxelles[5]—were for decades extracted, reprinted, and generally left to stand as authoritative. Only Lionello Venturi continued, in the years prior to the appearance of Rewald's *History*, to keep a fresh eye on what had once constituted the veritable cornerstone of modern art.[6]

Once Rewald's *History* appeared, all of the evidence incorporated into the discourse regarding impressionist art changed. With the art itself momentarily uninteresting, Rewald introduced *very* interesting texts—enormous quantities (increasing with each new edition) of contemporary documentation, largely consisting of contemporary critical extracts or artists' letters and/or statements. Rewald clearly wanted to accomplish two things, and he succeeded in both. First, he wanted to initiate a "scholarship" on impressionism (as opposed to an intelligently extended appreciation), and second, he wanted that scholarship in its documentary intricacy to help firm up the aesthetically insecure status of the historical impressionist achievement. Fortunately, in the second task he was immeasurably assisted in the 1950s and early 1960s by Clement Green-

1. *Manet and the French Impressionists*, trans. J. E. Crawford Fitch (1878; London, 1910). First published as a pamphlet in 1878, this study was expanded in the 1910 edition.

2. *The History of Modern Painting*, 3 vols. (New York, 1896).

3. *The French Impressionists* (London, 1903).

4. *Modern Art*, trans. Florence Simmonds and George W. Chrystal, 2 vols. (New York, 1908).

5. *Histoire générale de l'art français de la Révolution à nos jours*, 3 vols. (Paris, 1922). The painting section was first published in 1904.

6. *Les Archives de l'Impressionisme*, 2 vols. (Paris and New York, 1939); *Cézanne, son art, son oeuvre*, 2 vols. (Paris, 1936); and *Impressionists and Symbolists*, trans. Francis Steegmuller (New York and London, 1950).

berg,[7] Douglas Cooper and John Richardson,[8] and finally, William Seitz.[9]

In the first task, Rewald needed no assistance, as he opened for all to marvel at the immense verbal wealth of contemporary written documentation that lay waiting to be read in and around impressionism's history. The newspapers, journals, and ephemeral publications of the period combined with the innumerable stashes of letters and published interviews of one or another artist to make it possible for Rewald to present a history of painting in terms of a history of things written about it. Venturi had anticipated Rewald up to a point by his efforts during the 1930s to produce well-researched catalogues raisonnés of Cézanne[10] and Pissarro[11] and by his published assembly of the archives of the first and most important dealer in impressionist work, the firm of Durand-Ruel.[12] But what Venturi undertook to provide as reference material, Rewald absorbed and expanded with the continuous narrative of "documentary history."

In his *History,* Rewald adopted what he felt to be a "value-neutral" stance. Documents could speak for themselves. Being bits of writing and easily (more or less) translatable, historical accounting could be managed by the dispassionate act of documents deployed in sequence, with minimal comment (but not no comment at all) used to provide for transition, identification of authors, and other acts of certification. The very highest ideal of positivist historical writing, first defined by Leopold von Ranke, guided Rewald's enterprise from the beginning, and it

7. *Art and Culture* (1961; Boston, 1965).

8. *Claude Monet, Edinburgh Festival and Tate Gallery* (London, 1957).

9. *Claude Monet—Seasons and Moments* (New York, 1960).

10. *Cézanne, son art, son oeuvre.*

11. L. R. Pissarro and L. Venturi, *Camille Pissarro, son art, son oeuvre,* 2 vols. (Paris, 1939).

12. *Les Archives de l'Impressionisme.*

has continued in various, often quite subtle, ways to guide the
scholarship on the history of impressionism down to the present
moment.[13] With the exception of a few Ph.D. dissertations here
and there and the present author's own highly uninfluential
Studies in Early Impressionism (1973), virtually nothing that has
been written about impressionism has managed to avoid the
temptation of rummaging through, and rummaging through
again, the Pandora's box of Rewaldian documents.[14] To be sure,
Richard Shiff[15] may be looking for one thing (usually criticism),
T. J. Clark[16] for something else (usually criticism or omissions
from criticism), or Joel Isaacson[17] for any form of "straight"
statement (whatever that would look like), but these scholars,
like hosts of lesser ones, work and rework the same written
materials, sometimes referring to specific paintings, sometimes
not finding any need to. By 1986 and the production by various
scholars of *The New Painting: Impressionism, 1874–1886*, a mam-
moth catalogue for an almost equally mammoth exhibition
"documenting" the whole history of impressionist group exhibi-
tions, it was painfully clear that the analysis of documentation
was the historical discourse with regard to impressionist art.[18]

Had Rewald's *History* appeared at a different moment in the
developing historiography of art-historical writing generally, its

13. Ernst Breisach, *Historiography—Ancient, Medieval, and Modern* (Chicago, 1983),
232–34.

14. Champa, *Studies*. Although uninfluential, this book has been republished by
Hacker under the same title, *Studies in Early Impressionism* (New York, 1985). See Grace
Seiberling, *Monet's Series* (New York, 1981); and Richard Shiff, *Cézanne and the End of
Impressionism—A Study of the Theory, Technique, and Critical Evaluation of Modern Art*
(Chicago, 1984). Shiff's "Impressionist Criticism, Impressionist Color and Cézanne"
(Ph.D. diss., Yale University, 1973) was incorporated into his later book.

15. *Cézanne and the End of Impressionism.*

16. T. J. Clark, *The Painting of Modern Life: Paris in the Art of Manet and His Followers*
(New York, 1985).

17. *The Crisis of Impressionism—1878–1881* (Ann Arbor, Mich., 1979).

18. Charles S. Moffett, *The New Painting—Impressionism 1874–1886* (San Francisco,
1986). Interestingly, this publication is dedicated (in terms of scholarship) to Rewald.

effect would likely have been very different. But, in English-speaking countries, Rewald's book entered art-historical discourse at the very point when iconology as practiced most impressively by Erwin Panofsky was taking center stage, replacing (a sort of ill-defined) formalism as the most respectable approach to discussing works of art.[19] The traditional "humanist" underpinnings of iconology privileged reading over looking, and, of course, reading as an activity is substantially assisted by the presence of things to read—in other words, texts. What Rewald supplied was access to texts aplenty, and as a result the scholarly discourse on the history of impressionism became a progressively iconological one. This course of discourse is, however, a mildly surprising one, since by 1970 humanist-type iconology was beginning to appear a bit timeworn intellectually. How many humanist readers were there anyway, and more to the point, how many had there really ever been? Humanist iconology in its most elaborate forms required that there had been some (a fair number, at the very least a few) and that there continued to be some—at least one more than the rather easily counted number of Panofsky disciples.

Humanist iconology collapsed as a truly live intellectual discourse in the history of art as soon as "who is (was) the reader/spectator?"–type questions began to be asked. The questions were asked increasingly as French structuralist and quasi-Freudian texts (covering almost anything) began to appear in translation (some scholars even read them in French, before they were translated!). George Kubler, who as a Focillon student read French easily, and, one presumes, constantly, struck the first blow for an anthropology- and linguistics-based (Lévi-Strauss) replacement for iconological (humanist) modes of textual decoding (reading) in his 1962 *Shape of Time* (New Haven). In some-

19. Michael Ann Holly, *Panofsky and the Foundations of Art History* (Ithaca, N.Y., 1984).

thing less than a decade, Kubler's rather slender instructions had developed a degree of functional currency, so that what is now loosely termed structuralism dictated the manner of approaching both documents and nondocuments (things like paintings), all of which, written or not, were now texts.

Everything being a text, whatever was already written or easily reducible to written form, became prime intellectual property. Wherever there was something to read (literally) or read at (figuratively), art historians in sizable numbers did so, and they did so from a variety of methodologically self-interested positions: semiotic ones, Freudian ones (now called Lacanian ones), Marxist ones, and feminist ones. From many ingenious graftings the present-day poststructuralist permutations emerged in sometimes predictable, sometimes unpredictable, sequences.

What is important in all this for present purposes is that Rewald's documentary treasures have remained continuously alluring through the period of art history's metamorphosis from humanist iconology to poststructuralism. Whether pleased or not, Rewald has lived to see his materials become all written things to all reading women (men). To his credit, Rewald has not in revisions of his *History* undertaken to reinflect the material he first assembled. In his own work he has remained the "perfect" positivist, assuming words say what they appear to say, more or less. He has left the comparatively simple analysis of political posturing of the words to his most methodologically conservative follower, Robert Herbert,[20] and to Herbert's myriad students, especially Paul Hayes Tucker.[21]

But one wonders in retrospect how truly "perfect" Rewald's positivism has been. Is there in fact no authorial voice in his text? Of course there is a voice; no text lacks one. The question is, what is Rewald's voice, and what does it say even while

20. *Impressionism: Art, Leisure, and Parisian Society* (New Haven, 1988).
21. *Monet at Argenteuil* (New Haven, 1982).

attempting not to "say" anything? Without intending to be seen
as engaging in doctrinaire deconstructionist tactics, it is possible
to suggest that Rewald's primary voice (his 1946 voice) was *very*
period-reactive. The period was that of the Second World War
and Rewald, like so many other scholars, was on the run, either
from Nazi Germany or from Vichy France (pretty much the
same thing). Fantasies of a truly progressive and evolutionary
golden past, where the liberal good guys persisted to defeat the
reactionary bad guys, could hardly have been kept in check by
intellectuals or even subintellectuals. Rewald's surprisingly un-
controlled condemnation in his *History* of the aged collaboration-
ist, Camille Mauclair, testifies quite clearly to the existence of
less than neutral, and less than "pure" positivist sensitivities
(611).

The chief virtue of Richard Shiff's carefully argued revision-
ist overview of Rewald-type documentation has been to re-
move, or at least to question seriously, the need for an overarch-
ing evolutionary or progress notion to account for the strictly
impressionist or impressionist/postimpressionist accomplish-
ment. Yet in order to manage this, Shiff has himself remained
largely within the confines of written sources, working with
slippages and ambiguities in contemporary critical discourse to
underline the absence of certain consensus operating terms that
he feels would need to be in place in order for there to be a
certifiable change of the reception or description premises em-
ployed to account for impressionist or symbolist-type work.
But Shiff, in spite of his scholarly caution, never seriously ques-
tions "contemporary criticism" or "personal documents of the
artist" as primary interpretive source materials. In this he re-
mains Rewaldian, even while opposing his predecessor in cer-
tain basic ways. Shiff is Rewaldian because he ultimately be-
lieves in the transparency (or at least the near transparency) of
contemporary written "documentary" accounts. Or to put it
another way, Shiff, like Rewald (and innumerable others) is,

while proceeding with varying degrees of methodological refinement, a residual documentary iconologist refined in certain ways by semiotic theory. He privileges above all what he can find to read.

While there is certainly nothing wrong (in principle at least) with relying on the analysis of texts to initiate and guide the interpretation of nonwritten works of art—in this instance, paintings—there is a problem when the analysis becomes so thoroughly self-referential as to reduce the prime objects to the status of secondary referents. I have argued on many occasions in the past that when paintings are exclusively indexed by what is written about them, they become sensuously lifeless and hardly worth "serious" attention as specific, rather than generic, cultural and aesthetic occurrences.[22] The documentary scholars most sensitive to this potential for the subject (the paintings) to collapse under the burden of writing are, in the instance of impressionist studies, somewhat surprisingly, Herbert and Shiff. Both seem to envision the function of their analysis of written texts as a path that, if followed, places them as authors in the position of suggesting a fuller aesthetic as well as contextual account of major aesthetic achievement. Sometimes Herbert succeeds—in the best of his "storytelling" descriptions of impressionist pictures. Shiff nearly always manages to keep lines of communication open and operative in both directions between his texts and his paintings. Yet for both authors there is always in their writing a sense of strain—a kind of tightrope being walked between two points of discursive emphasis. The rope is pulled tighter and tighter, but the points never really get any closer.

Short of restricting oneself exclusively to simplistic formal analysis, is there any way to envision a use of written texts in the discussion of nonwritten ones that could operate without the tensions implicit in Rewald and very explicit in Herbert and

22. *Studies*, xiii–xviii; *Rise*, esp. 34–41.

Shiff? I would argue, albeit self-interestedly, that there exist at least a few alternatives that can with some confidence be noted. Michael Fried's highly controversial studies of Courbet and Eakins, while only marginally relevant to issues raised by impressionist or symbolist painting, nonetheless demonstrate a pattern for the bonding of sustained visual experience to supportive, or at least suggestive, examples of written documentation.[23]

Often looking quite "documentary," Fried's essays ultimately look more like looking: Fried seeks out in highly ingenious and unpredictable ways written (documentary) help in explaining what he has already perceived to be visually operative in particular paintings. His experience and his extensive self-marination in that experience (his phenomenological engagement) dictates the written confirmations he wants to find, and he is remarkably successful at finding them. His documentation is never so obviously "hard" as that characteristic of Rewaldian contextual scholars (iconologists as defined above), but it is more compelling in terms of its effect. Fried always looks outward from what he has seen, and since he never ceases looking, what he writes and cites develops as a seamless critical and intellectual whole. Fried cites "selfishly," judged by positivist standards, which is another way of saying that he uses what is useful to him and largely ignores what isn't.

Without presuming myself to have tracked Fried's example in very precise ways (particularly as that example contains a degree of sophisticated immersion in contemporary French critical theory that I neither can nor want to emulate), I admit to boundless respect for his work and for the way he goes about doing it. In the comparatively few published instances (for example, *Rise*) where I have stepped gingerly beyond the confines of strictly formal discussion, my course has been guided more by

23. *Courbet's Realism* (Chicago, 1990); *Realism, Writing, Disfiguration: On Thomas Eakins and Stephen Crane* (Chicago, 1987).

Fried than anyone else. Like him, I have looked for *useful* evidence (whether hard, reasonably hard, soft, or very soft) in order to elaborate or in some way confirm what on the basis of visual experience I had come to believe was the case in a given painting or group of paintings. For better or worse my recent *Rise of Landscape Painting in France: Corot to Monet* serves to demonstrate my documentary "selfishness" in very clear terms.

The use of the term "selfishness" with regard to documentation will undoubtedly raise a fair number of scholarly red flags. So be it. I consider *all* use of documentation to be "selfish"; that is to say, ideologically self-serving. The fact that I emphasize "selfishness" in Fried's scholarly behavior and my own must not be taken as truly exceptional, but rather as demonstrative of certain scholarly or critical extremes that simply underline operations characteristic of the entire range of art-historical writing on impressionism and everything else that is "historical."

It borders on intellectual nihilism (and current intellectual trendiness) to suggest that support for the contention that all use of documents is "selfish" lies in the act of insisting that the kinds of texts cited by scholars in historical studies say nothing until they are made to. In making texts say something, authorial desires necessarily creep in to provide order and substance. Obviously some texts are more mute than others, but the most mute (particularly in the modern period) are very frequently those that on the surface appear least so. A medieval charter, a probate document, or a birth certificate may be because of period legal archaisms and conventions of language difficult to penetrate, but the penetration difficulties there are quasi-finite compared to the wildly unstable variables (positively overwhelming in type and in number) that surround the texts of known (by name) authors of both public and private documents that form the bulk of the documentation available to historians of nineteenth-century materials. Writing more than a decade ago, Anne Coffin Hanson described the situation very suc-

cinctly: "The art historian, attuned to proving influence and connection by discovering treatises and documents must admit defeat before the wealth of material to be found in the nineteenth century. There is both too much repetition of ideas to establish single and clear connections and too little specific evidence to cement profound conclusions. The very confusions of the era will offer for each discovery an equally relevant contradiction. The only choice then is to follow the path of common sense and try to feel one's way to an understanding of that life itself."[24]

I would agree with Hanson regarding the sheer problem of textual quantity, but as just suggested, the character—the usually first-person character—is arguably more troubling. Personal letters and signed criticism appear to be the most useful, potentially accessible, and quantitatively rich kind of documentation that one could hope to find. The knowing of who is writing and what she is writing about, the comparative and cross-referencing possibilities, the general sense that one is dealing with people talking in writing and able to be listened in on—all of this suggests a degree of reliable transparency that unfortunately does not bear up to serious scrutiny. Even semioticians, the most responsible ones at least, can never be absolutely certain why particular persons say or write exactly what they do when they do it. To be sure, some consistent operations of signage ought to be in place, but when, and how firmly?

Following Hanson's suggestion to be guided by common sense, one wonders how to proceed with—to choose an arbitrary starting-point—personal letters. Since everybody writes letters, anybody ought, it would seem, have some clear notion of how they work. As an experienced writer and receiver of

24. *Manet and the Modern Tradition* (New Haven, 1977), 37.

letters, one knows that letters are (1) written to someone in particular; (2) about something or somethings; and (3) in a way of writing devised at a particular moment to inflect what is being said so that it is readable in a predetermined way by its recipient. If one is neither the writer, nor the recipient, and not experientially privy to the "real" ambience of a letter, what is one in all honesty to make of a letter? Obviously, one can make of it what one wants, relying to a greater or lesser degree on whatever experience or "common sense" one thinks one is able to bring to bear. A letter can be said to be "straight," formulaic, polemical, ironical, or any number of other things in order for the nonrecipient reader to make sense of it. But whatever is decided about the letter, the decision is necessarily contentious. Another nonrecipient reader might very well make totally different determinations, and for equally commonsense (or at least pretending to be commonsense) reasons.

When there exist two sides of a body of correspondence the situation is somewhat different, although not so different as one might like it to be. Statement-response situations certainly offer greater potential transparency than statement-only ones. But, lamentably, these situations are more exceptions than rules in later nineteenth-century art-historical documentation. In those rare instances when two-sided correspondence exists, the possibility of sorting out the rhetorical politics operating between writers invariably looms large. Whether the sorting can ever be managed conclusively remains always an open question.

A second type of document routinely encountered in impressionist studies (as elsewhere) is the "artist's statement," usually conveyed via some manner of fictive interview form. While often used by Rewaldian historians, most agree that this species of documentation is potentially useless, since it is generally much after the fact and highly colored (if often invisibly so) by the interviewer, and subject to the combined special interests of the moment of both the interviewer, and the artist/statement-

maker. Both Monet and Manet have much in the way of "state-ments" attributed to them, but certainly Renoir and Cézanne have quantitative pride of place in this regard. Yet, in spite of the notorious slipperiness of such documents, even a scrupulous modern documentary scholar like Herbert (*Impressionism*) yields to the temptation to incorporate in his discussion of Renoir not only Vollard's posthumous "interviews" of Renoir but the wildly distant and massively self-aggrandizing memoirs of Jean Renoir, the artist's son. Charming as they often are, it seems that random artists' statements of all sorts ought to be treated *very* suspiciously as reliably usable texts. They are of the most broadly unstable sort, whether considered historically in terms of appropriate date *or* viewed as certain traps into intentional fallacies.

The third conventional type of text-document common to impressionist studies is the critical essay or review (contempo-rary). Potentially, this is the most intellectually "high-powered" type of writing in the nineteenth century, since so many inarguably major writers produced substantial quantities of painting criticism. There are big names everywhere, beginning with Théophile Gauthier, Charles Baudelaire, and Jules-An-toine-Félix Husson (Champfleury) and continuing ad infinitum through Zola to Jules Laforgue, Gustave Kahn, Félix Fénéon, Albert Aurier, and many others. So many writers of major stature participated in the critical arena after 1830 that criticism, probably rightly, has been the focus of the most ambitious and intellectually intricate documentary study. Without the enor-mous body of period criticism to work with and from, Re-wald's *History* would never have come into being, and the works of Shiff and Clark not even conceivable.

Shiff's use and analysis of criticism is by all odds the most subtle; Rewald's is the earliest and understandably the least, and Clark's somewhere in between. The only prior standards by which Shiff's analysis can be measured were those estab-

lished by Sven Loevgren.[25] Shiff and Loevgren have much in common in terms of the way they rely on the seemingly transparent discourse of contemporary criticism. Both treat it as though it were or might be conceived to be of the intellectual discipline and substance of serious aesthetic philosophy. And why shouldn't they? Some of the very best minds in nineteenth-century France were writing criticism, so either it *was* a very serious arena of discourse, *or* there was a very large market for criticism, no matter how serious it was. What both Shiff and Loevgren trace are the apparent patterns of introduction and definitional refinement of key critical terms. They assume much consistency of intelligent concentration on the part of individual critics and a persistent reactivity between critics. At base both Shiff and Loevgren want to see evolving aesthetic theory latent in published criticism of the most ambitious sort. Choosing their examples carefully and fine-tuning their analyses, both scholars manage more or less successfully to find what they want: Shiff a continuously developing impressionist/symbolist language of theory, if not a full-blown formal theory, and Loevgren a powerfully unified symbolist one.

Besides repeating the suggestion that scholars (if they are any good at all) tend to discover in carefully selected texts and in carefully directed analyses of those texts precisely what they are looking for, a few comments need to be added in order to position properly the use of contemporary criticism. To begin with, it is important to have one's critics writing about what one wants them to be writing about, and nothing else. This may mean the ignoring of many writings about inconveniently "unrelated" matters—music, for example. Then it is equally important to insist on pervasive intellectual integrity and consistency

25. Sven Loevgren, *The Genesis of Modernism: Seurat, Gaugin, Van Gogh, and French Symbolism in the 1880s*, rev. ed. (Bloomington, Ind., 1971).

on the part of those writing contemporary criticism. How Loevgren managed the level of belief that he had in the consistent seriousness and focus of contemporary criticism, I cannot judge, but in Shiff's instance, the situation seems much clearer.

Shiff was a graduate student at Yale during what was by general agreement the "great period" of contemporary art criticism in America. He knew the Greenberg and Greenberg followers' production extremely well. Criticism as hyperserious discourse was a live experience for Shiff; even though he didn't practice it, he certainly knew what the intellectual stakes were, and he has never forgotten. However, Shiff's transposition of "his" contemporary experiences back onto the 1870s and 1880s may be more wishful than ultimately demonstrable.

Is it significant that Shiff (and Clark), among recent scholars, intellectually idealize criticism in a way that those of us who have practiced it more or less extensively and more or less continuously do not? Besides Fried, David Carrier and I have personally waded through the mud of contemporary criticism, and none of us seems as a result (with Fried as a highly sophisticated and qualified exception) to take earlier criticism at such serious intellectual face value as do Shiff and Clark. What can be deduced from this? Perhaps something fairly simple. To practice anything is to become suspicious of the practice to some degree. Not to have practiced is to be potentially gullible to much overestimation and aggrandizement. The peculiar politics of contemporary criticism as an "intellectual" activity literally have to be felt.

From all of the above it should be reasonably clear that I entertain both in principle and in detail a considerable number of reservations regarding what has come to be seen as the documentary history of impressionism. This is not a new situation of doubt for me, but it is one the magnitude of which has increased quite remarkably over the past decade. There is a void (or per-

haps several voids) in the published documentation of the "progressive" in French painting of the 1870s that perplexes me. Something I believe to have been very important went underground, falling out of most personal and nearly all published discourse. That something was open discussion of the aesthetic master model of German music, and especially Wagner's.

During the 1860s in France the discussion was operative virtually everywhere and directed toward all the arts. As a cultural and political forbidden fruit after the Franco-Prussian War, the "modern German music" issue was, it seems, largely undiscussable for nearly fifteen years. At least it was undiscussable publicly. But was it inoperative privately? Certainly not. Bayreuth was happening and everybody knew it. Modern German concert music remained alive and well in Brussels and London, and more than a few French nationals were hearing it, if not in the orchestral flesh, then at least in the privacy of their homes in piano transcriptions. Wouldn't it be nice to know exactly what Manet's wife performed or had performed to assembled friends in the evenings of the 1870s? And where did Renoir and Fantin-Latour go for their Wagner fixes in the same period? By the end of the 1870s there is not so much mystery, as the broad circle of Wagnerist "friends" becomes increasingly visible publicly and Parisian orchestral concerts become less parochial, if only gradually so.

Viewing the Wagner situation from the strict perspective of progressive French music in the 1870s, the immediate post–Franco-Prussian War period, the seemingly forced silence on the "modern painting/modern music" issue becomes especially intriguing. But the purely musical situation in France *was* different and Wagner, in spite of his increasingly annoying public francophobia, had penetrated advanced French musical taste and compositional practice so thoroughly by 1870 that, national embarrassment aside, he could not be marginalized. True, his music might not be performed publicly for a few years, but César Franck and his coterie of students, along with

Delibes and Saint-Saëns and later Chabrier, Massenet, and Fauré recognized their musical debts routinely, at times swallowing their national pride willingly, at times not. Many of the French went to Bayreuth after 1875, but even before that Saint-Saëns, who would later (wherever politically expeditious) be vocally (and publicly) the arch–anti-Wagnerist, gave a benefit concert in the town of Bayreuth as the cornerstone of the new Festspielhaus was being laid.[26]

By 1880 Wagner was again a designated cultural neutral and was officially approached by representatives from the French ministry of culture for recommendations on the naming of the head of the composition program at the Paris Conservatoire.[27] Even before this, in 1875, it had been a French national (or at least marginally so, since he was Alsatian), Edouard Schuré, who produced the first extended analysis of Wagner's role in the development of music after Beethoven.[28] Schuré, along with Judith Gauthier and Villiers de l'Isle Adam had suffered through the first weeks of the Franco-Prussian War as guests (more or less comfortably willing ones) of the Wagners on Lake Luzerne, and Mallarmé, whose years of "writing block" came on the heels of the war, and perhaps traumatized by the political and cultural turns of events vis-à-vis Wagner, returned to semipublic view only after Wagner's death and during the founding period of the *Revue Wagnérienne,* to which he contributed significantly. Wagner had been *the* modern artist for the whole gallery of Mallarmé's early literary saints: Baudelaire, Champfleury, and Théophile Gauthier.

In the 1860s, the developing years of impressionist painting, a taste for Wagner and for modern painting, essentially Manet's,

26. Cosima Wagner, *Cosima Wagner's Diaries,* 2 vols., edited and annotated by Martin Gregor-Dillan and Dietrich Mack, trans. Geoffrey Skelton (New York and London, 1977); see entries for 1873 and 1874.

27. Ibid., entries for 1880 and 1881.

28. *Le Drame Musical,* 2 vols. (1876; Paris, 1886).

had gone had in hand. Renoir and Fantin-Latour were the Parisian-born fans of Wagner's music. Bazille, with his friend and survivor into the 1880s, Edmund Maître, as well as Cézanne, and Zola all brought their enthusiasm with them from the south. It is hardly an exaggeration to say that impressionism and Wagnerism grew up together in Paris in the 1860s. What happened in the 1870s? Why is it not until 1883 that the poet and critic, Jules Laforgue, reintroduces the connection in a positive light—not until the year both Wagner and Manet died?

The commonsense answers to these questions are fairly easy to provide. Anti-German sentiment in France was understandably high in the years following the Franco-Prussian War and the result was the predictable popular slandering of most things German or "Germanic." Wagner was a widely known cultural figure to readers of the French press before the war, so he was a perfect target either for omission from cultural discourse or for citation of aesthetic rottenness afterwards. For any writer intending to support modern artistic effort (impressionist painting, for example) in the years after the war (the 1870s), any mention of Wagner's music as being in any sense parallel in character or accomplishment would have backfired. It was best for the impressionists and their largish group of more or less enthusiastic critics simply to keep their mouths shut about Wagner, at least for a time. Those unsympathetic to the impressionist efforts were more likely to introduce Wagner, but as an aesthetic negative.

Silence on the comparative consideration of Wagner and impressionism (however conceived) was of sufficient chronological duration to make Laforgue's reintroduction of the practice in 1883 exceptionally difficult to interpret even today, perhaps more difficult than it was at the time it appeared. Writing more than a century later about the Laforgue article that discusses comparatively Wagner and impressionist painting in highly

imaginative and often surprising terms, Clark literally throws up his hands. Unable to imagine exactly why Laforgue was doing what he did in likening the "strands" of impressionist color to Wagner's "forest and voices," Clark, so to speak, signs off, saying, "These epithets and analogies are foreign to us now, but it seems safe to answer that there was something in the paintings that originally produced them" (*Painting of Modern Life*, 17). He then proceeds to work with the not very interesting assumption that it was the "strangeness" of impressionist pictures that induced Laforgue to introduce so strangely and so unexpectedly the "strangeness" of Wagner's musical effects in order to cross-reference impressionist "strangeness." We don't really learn very much from Clark's explanation. We actually learn more by simply noting that Laforgue, like a not inconsiderable number of other progressive French intellectuals, had after 1880 made comfortable and rewarding reconnections with, even visits to, his peers in Berlin. Once this situation developed, the seal on Wagnerist/impressionist parallel discourse was broken, and the way cleared for a broader public discussion of Wagner to develop in France and to become fundamental to the birth and maturity of the aesthetics of symbolism there.

We will probably never know with any certainty of conviction what transpired in silence under the decadelong seal on the open discussion of relationships or distinctions, known or perceived by the major aesthetic operatives in France, between advanced German music and advanced French painting in what were the truly key years in the latter's move into the public spotlight. There is plenty of circumstantial evidence of the likelihood of ongoing sensitivities to at least the question of parallel aesthetic operation. Probably the most tantalizing has to do with the persistent friendship through the period between Manet and Chabrier, and the latter's avid collecting of impressionist pictures, as well as his equally avid study of Wagner's scores.

The aesthetic counterpoint represented by this must somehow have felt right, at least to Chabrier, and, by implication perhaps, to Manet as well.

As I noted in 1974, to be seconded by Shiff a decade later, there was a brief moment in the early 1870s critical discourse on impressionism in France when generic references to the musicality of impressionist practice were emphasized.[29] But Wagner is not mentioned, nor is any other composer by name, and the issue passes quite rapidly, so rapidly that one sees hardly a trace in Rewald's narration of the history of impressionism. It must be emphasized again how truly mysterious this void of discourse is, particularly since virtually all contemporary commentators on the symbolist art of the late 1880s emphasize the musical aesthetic master model as a matter of routine.

The most ambitious early histories of "modern French" painting, those written between 1890 and 1905, make no attempt to signal internal interruptions in their musical model-laced discourse. For them that model functioned seamlessly in French painting from 1860 onward.[30] Here again one must cite the conditioning power of Rewald's *History*—this time in its influential moving of the issue of music (which always *means* Germany) out of the picture of the 1870s. His management of this, politically motivated or not, was enormously skillful and seemingly unforced. Historians of symbolist art, including, besides Rewald himself, Rookmaker, Loevgren, and Roskill, accept virtually without question the notion of the French and symbolist-specific emergence of musically modeled aesthetic operation.[31]

29. Champa, *Studies*, 96–99; Shiff, "The End of Impressionism," in Moffett, *The New Painting*, 61–86.

30. Champa, *Rise*, 58–59.

31. H.R. Rookmaker, *Synthetist Art Theories—The Genesis and Nature of the Ideas on the Art of Gaugin and His Circle* (Amsterdam, 1959); Loevgren, *Genesis of Modernism;* and Mark Roskill, *Van Gogh, Gauguin, and the Impressionist Circle* (Greenwich, Conn., 1970). See also A. G. Lehmann, *The Symbolist Aesthetic in France: 1885–1895* (Oxford, 1950).

Only Shiff has resisted, but without arguing the question in any depth.

Granting, as I already have, that there is only scattered circumstantial evidence of a conventional sort to argue for a kind of self-imposed censorship in the critical record of impressionism during the 1870s on the issue of the musical (Wagnerist by now) master aesthetic model, where is one to turn for any kind of "unconventional" textual support? As I do not myself make any categorical distinction between the utility (and/or reliability) of conventional versus unconventional texts, I am perfectly willing to consult what is seen in the broad, scholarly consensus to be the most *unreliable* historical text of the period, Zola's novel, *L'Oeuvre.* The novel was not always seen as thoroughly unreliable: it creeps clearly into Richard Muther's history and into British journalism of the 1890s, and echoes less clearly in the pre-Rewald bibliography on impressionism for half a century.[32] But I would agree with the modern view that it is unreliable. That is not to say that I think it not worth examining as more than just a novel. Lacking other contemporary texts treating continuously the 1867–1885 period (roughly speaking), we have no choice but to pay at least some attention to the book. At least I have no choice, since I want to trace, if only via verbal shadows, some features of aesthetic continuity through the period of critical silence on the cross-referencing of advanced music and advanced painting (and perhaps even advanced writing).

I am "going into" Zola looking, selfishly as I have defined it, for something that I deeply believe to have been continuously part of the history of impressionism; namely, the persistence of the musical master model, even when the model seems in its textual imprints no longer visible. I well recognize that what I will find and what I will argue about what I find will be subject to

32. Douglas Cooper, *The Courtauld Collection* (London, 1954), 43; and Muther, *History of Modern Painting.*

much scholarly doubt regarding objectivity and detachment. But I make no claim for having, or for the matter even honoring, those "virtues" overmuch. In my discussion of *L'Oeuvre* I will have succeeded if there emerges an interesting argument that is even vaguely convincing. I will have failed only if the interpretation becomes boring and/or disrespectful of the subject.

I've already described in Chapter 1 how and for how long *L'Oeuvre* has been one of my (arguably many) neurotic intellectual obsessions. I refer to that here to avoid appearing to be involved (at least intentionally) in a postmodernist form of discourse. I do not feel "lost" intellectually, and I am not in this book collaging texts because I am uncertain of direction. Rather, what is presented here is an attempt to critique and to adjust (or recalibrate) historical discourse on the history of impressionism. I am doing this by returning at whatever risk and for whatever selfish reasons to what I would argue to be the first, the most interesting and provocative, *and* the most purposefully flawed "history," namely, *L'Oeuvre*.

To approach *L'Oeuvre* is to attempt to give an account of the literary picturing of picturing—or to put the matter more obscurely—to repicture the novelistic picturing of picturing. I intend at the same time to treat the book, even though it is a novel, as though it both were and were not one. This is, in my judgment, a thoroughly fair way to proceed, whether Zola might have agreed or not (I suspect he would have). In undertaking to treat *L'Oeuvre* as novel *and* history it should be stated in advance that, as I do so, I am also considering Rewald's *History* as both history and novel, which I think it is, for various reasons already discussed. Neither text, Zola's nor Rewald's, is purely one thing or another, but Zola's is the more honestly ambiguous, since it deploys its mistakes (its fictions) clearly, while Rewald's does not.

If *L'Oeuvre* and Rewald's *History* are both to be treated as fictions, the question immediately arises: Which is the better fiction? Here, Zola wins hands down, since even with all the typical Zola flaws of style, the poor editing, the self-indulgent rhetoric, *L'Oeuvre* is a formidable piece of literature; Rewald's history (if judged as literature) is not. From a strictly literary point of view Zola at his weakest is a giant of prose writing, compared to Rewald at his strongest. And Rewald is always at his strongest when he is quoting. Is it fair to compare the two texts this way? Rewald, after all, was not consciously intending to write a piece of strong fiction. Yet, I would argue, that is precisely what he produced covertly. Had his work been treated when it appeared as the particular species of fiction it was, it might never have achieved what is in the present writer's view its insidiously pervasive and largely unquestioned textual status as prototypically neutral and objective historical reportage. With so many historians (and semioticians) today moving consciously, comfortably, and easily back and forth between "accounting" and en-ficting modes, it seems altogether appropriate to point out that in Rewald's case the undeclared (even unrecognized) en-ficting can simply be excused as a function of the old-fashioned neopositivism of both the author and scholarly audience he confronted, and to a degree continues to confront.

Zola was by all definitions a realist novelist, and in fact the generally recognized inventor of the species. In *L'Oeuvre* he was, with a few interesting exceptions, continuing to write on the pattern (or with the system) that had, by the time of *L'Oeuvre's* appearance, gotten him beyond the halfway point in his projected twenty novels forming the Rougon-Macquart series. While noticeably shorter than its immediate predecessors, *La Joie de Vivre* of 1884 and *Germinal* of 1885, *L'Oeuvre* has many special features that appear in it and nowhere else in Zola's writing. Only in

L'Oeuvre does Zola prominently implant a character that is in some fictive transformation intended to be read as himself.[33] And only in *L'Oeuvre* does Zola array an entire cast of characters who might be imagined as "representing" with varying degrees of clarity and explicitness, "real" people who had been large characters in Zola's "real" life.[34] All of this being the case, it is obvious that the author was counting on the phenomenon of fleeting recognition of living figures already known in greater or lesser detail to a large segment of his readership. By proceeding as he did, cultivating "fleeting recognitions," Zola also assured that his novel and its realism—however one wants to define it—could create believable ambiguities of people, time, and place. In *L'Oeuvre* he uses this particular condition of simultaneous reader curiosity and entrapment to address at his own novelist's and quasi-historian's pace the intellectual and social occasion of the novel.

Appearing in 1886, *L'Oeuvre* entered an artistic scene of a very pronounced character: a scene in which the novel itself, for perfectly understandable reasons, would ultimately become a significant part. Yet the novel makes its entrance seeming to be about the past rather than the present, and that past as it approaches the present in Zola's novel does so at the author's speed and on the author's terms. *L'Oeuvre* is a novel that is, above all, about portrayal and it assumes (interestingly) a broad-based audience well-informed regarding aesthetic debate in France's own recent past. By the time of the writing of *L'Oeuvre*—it had been projected fifteen years earlier in Zola's outline for his "series"—Zola had become a master at "portray-

33. Patrick Brady, "Pour une nouvelle orientation en sémiotique: A propos de *L'Oeuvre* d'Emile Zola," *Rice University Studies* 63 (1977): 43–84. On p. 47, Brady also cites his *L'Oeuvre d'Emile Zola, roman sur les arts* (Geneva, 1967).

34. Robert J. Niess, *Zola, Cézanne, and Manet* (Ann Arbor, Mich., 1968). See also Roger Ripoll, *Réalité et mythe chez Zola* (Paris, 1981), 759–75.

ing," which is why a novel like *L'Oeuvre* can operate (and did operate) as history as well as fiction.[35]

One of Zola's most significant maneuvers in the practice of writing novels was his substitution of unprecedentedly extended quantities of authorial description for dialogue. *L'Oeuvre* is a masterpiece of description, and it is so at the moment Zola selected to write about description (or representation) in all its medialogical manifestations. Still-life, as well as not so still-life vignettes, drive the book and become the main devices for Zola's preservation and advancement of spectatorial (reader) recognition and control. Written picturing is everywhere, beginning on the first page when the author introduces visibility blindingly with the "electric" flashes of lightning that give the reader his first glimpse of the "novel's" Paris. From there on Zola sets and advances every narrative scene by "painting" it first in general aspect and then in detail. Contemporary readers familiar with the author's style to date may not have been exactly surprised at his painting mode as practiced in *L'Oeuvre* (it was already much imitated by followers like Huysmans) but the new feature is that the scene changes are executed with descriptions of effects that are more visually than sociologically or psychologically informative: the book ultimately feels pictorial in form as well as in content.[36]

L'Oeuvre is on several levels an extended conversation between writing and the pictorial arts—perhaps even a competition, testing powers of representation, with the novelist utiliz-

35. David Baguley, "*L'Oeuvre* de Zola: Künstlerroman à thèse," in *Emile Zola and the Arts: Centennial of the Publication of l'Oeuvre,* ed. Jean-Max Guieu and Alison Hilton (Washington, D.C., 1988), 185–98.

36. Bettina Knapp, "The Creative Impulse—to paint 'Literarily': Emile Zola and the Masterpiece," *Research Studies* [Washington State University] 48, no. 2 (June 1980): 71–82; Joy Newton, "Emile Zola and the French Impressionist Novel," *L'Esprit Créateur* 13, no. 4 (1973): 320–28; and John Frey, *The Aesthetics of the Rougon-Macquart* (Madrid, 1978), 64–68.

ing to the full the writer's freedom to play off movement and stasis in representation, and to do so at will.[37] Throughout the book, painting, especially Claude Lantier's unnamed and unfinishable "masterpiece," is misguided by a self-frustrating program intended to accomplish a range of representation, using descriptions of both an illusionistic and allegorical sort that, lacking a system to guide technique (or style in Zola's terms), refuse to come together. Painting is defeated in the contest of representation in Zola's novel, and, reading between the lines, one sees that it is beaten by a combination of problems, by the tendency of the new painting to seize effects too rapidly, and by the not comprehending of how to form them knowingly.

As already suggested in Chapter 1 there is a great deal of aesthetic politics flying around in *L'Oeuvre*, particularly vis-à-vis Manet's *Bar at the Folies Bergère*, which like many other Manets doesn't conveniently fail in Zola's fictional terms. A misrepresented fictive masterpiece project is invented by Zola for the clear purpose of creating a failure that never was, but that might easily be imagined as having been. Without reviewing these earlier observations further it is important to keep in mind that the context of representation—in terms of the power of the medium engaged in the representational act—is that aspect of *L'Oeuvre* that makes the book a good deal more than the midpoint in the broad nineteenth-century fascination with artists as major characters in stories (long and short) and with the mysterious ambiguities of their visual conjuring. The oft-cited trilogy of major works in the genre includes first, Balzac's *Chef d'Oeuvre Inconnu*; second, *L'Oeuvre*; and finally Wilde's *The Picture of Dorian Gray*.

Both Wilde and Balzac were broadly fascinated by the other-

37. Werner Hofmann, "Der Künstler als Kunstwerk," *Deutsche Akademie für Sprache und Dichtung Jahrbuch* (1982), 50–65; Pierre Aubéry, "Zola peinture et la littérature," in Guieu and Hilton, *Emile Zola,* 1–8.

ness of painted as opposed to written representation. In the latter's case that otherness approached and finally collapsed into invisibility or the complete opposite of representation, unless of course representation is redefined as medium specific self-representation. This redefinition is not very overt within Balzac, Wilde, or Zola, largely, one suspects, because it exposes writing's weakest side. It is difficult, arguably impossible, for writing effectively to "not represent," or to be abstractly itself. Baudelaire realized this acutely, judging writing against music.[38] Zola, one could argue, saw for the first time the potential for painting to join forces in "abstractness" with music. The fact that painting had not absolutely managed to do so by 1886 does not contradict the suspicion that Zola smelled the situation developing and that he saw the situation immanent in the processes of impressionist painting where splendid effects were left free-standing, "unfinished and unfinishable" in Zola's terms, yet troublingly "truthful" and complete in themselves, *and* relying not at all for their sensation of truth on the subject represented. Subjects were very important things to Zola. The whole theory and practice of the realist novel elaborates the subject as perhaps never before in major writing. The goal of representing social truth by exploring the physiological, psychological, hereditary, and environmental conditions of existence all at once required for its accomplishment carefully chosen (representative), clearly, and distinctly rendered subjects. The coefficient of observation and invention operative in particular subjects is, of course, variable, but in realist fiction the former must appear dominant. Language of the street, rather than literary language, privileging of the pervasive uncontrollability of the drives of sexuality, and complex plotting of the life/death struggle: these are (very simply stated) the essential technical features of the realist novel. They require for their proper functioning almost

38. See Champa, *Rise*, 33–34.

excessively recognizable subjects. Without them realism as both mission and style collapses.

What this means with regard to *L'Oeuvre* (the overall plot of which has been summarized concisely and well by Loevgren [*Genesis of Modernism*, 35–40] so it need not be repeated here) is that in the treatment of the subject a referenceable semblance of something like "historical reality" needs to be sustained regardless of the (I would argue) complex ideological maneuverings that Zola undertakes to manage his way around difficult issues of aesthetics. Exactly what is required for referenceable semblance in the instance of this book is difficult to describe because, one suspects, it was difficult to execute; in *L'Oeuvre* the historical component was (as already mentioned) a broadly known historical phenomenon: the emergence of impressionist painting. To put it differently, Zola had to feign more "history" or "apparent history" in *L'Oeuvre* than in any other of his novels, as his readers were more likely than not privy or at least semiprivy to key events and key patterns as well as key character types. Many from Zola's readership may well have been privy to these patterns and events over an extended period of time—as long or longer than the apparent time-frame of the novel itself.

Zola's authorial decision to appear to narrate an autobiography in the third person was ultimately both brilliant and useful. It gave him the opportunity to implant a realist literary ideology within the text as well as (being the author) standing in a position to coordinate the aspects of other characters to constitute "himself" as he wanted to be constituted. The "self" character of the author directs both the literary and historical traffic patterns of the book, but, being a character, it seems never to do so, since in classic realist-novel fashion, circumstances variously defined seem to dictate everything. Circumstances for Zola are both situations and behavioral acts (individual or collective) developing within them. Seemingly inevitable successions of cir-

cumstances are the locations of "history" in Zola's text. And a rather strange history it is.

L'Oeuvre is a history in which the count of years never truly adds up, where relative chronology is often uncertain, and where known or quasi-known characters flicker in and out of clear view. Only the character of Sandoz (the fictional author "self") seems absolutely present (or perhaps absolutely never present by being so present). Claude Lantier is the character most seen, as he is watched by both Sandoz and, of course, by the author who is devising him.[39] Every other character, including Claude's mistress, then wife, Christine, is puppetlike and very discontinuously (or shallowly) present through the novel. It is this that has encouraged some critics to contend that there is really only one character (with two fictive identities) in the novel: Sandoz/Claude, a complex creator of near (but not quite) genius, and, of course, male.[40] The male (or males) are driven to the virtually impossible (for various reasons) production of "masterpieces." That is what their life is about. It is their work *and* their life.

The flickering of Claude's identity as a "real" character back and forth from Manet to Cézanne to Monet provides one path of history through *L'Oeuvre*.[41] Claude is the convenient agent of events, achievements, and self-frustrations that Zola needs to install both his history and his ideological agenda into the activity of painting. Without needing to have the Franco-Prussian War happen or the impressionist exhibitions occurring (in fact, never even using the term *impressionist*) Zola gets enough narratively sequential behavior built into Claude to make of him a

39. See Allan H. Pasco, "The Failure of *l'Oeuvre*," *L'Esprit Créateur* 11, no. 4 (Winter 1971): 45–55, who suggests that the failure of the novel lies in Zola's rendition of Sandoz.

40. For a view of Paris as a character, see Jean-Pierre Leduc-Adine, "Paris et l'ordre spatial dans l'Oeuvre," in Guieu and Hilton, 165–75.

41. Niess, *Zola, Cézanne, and Manet*.

historical/biographical plausibility, if not a certain individual reality. Zola uses Claude to enact the technical and aesthetic history of impressionist practice—the first Salon des Refusés' triumph, the movement into out-of-doors work (and the concomitant production of brilliant "studies"), and the impotent collapse around the project for the masterpiece allegory of the city of Paris. The three stages of Claude's career appear roughly to represent somewhat abruptly first the 1860s, then the 1870s, and finally the early 1880s.[42] Sandoz's career is by contrast a continuous, cumulative evolution guided by the disciplined refinement of working method. It moves from promise, to first success, to established reputation (and economic prosperity). Between the two characters everything is very Darwinian and the fittest survives, but was the fittest the greater talent? By raising the question Zola is at his most honest.

Other characters in the novel enter and exit, reenter and reexit, to provide sometimes amplitude, sometimes just infill in Zola's narrative and its "history." Other media, sculpture and architecture, have their more or less convincing appearances in various characters, with architecture serving Zola his best opportunities to ridicule academic instruction, a minor subtext in the novel. Female characters both decorate and undecorate the text throughout. The strongest of them, Irma and Mathilde, count on sexual performance to propel their ways upward from the street to the heights of bourgeois respectability, wealth, and culture. The weakest, Christine, and in certain respects the rather dim character of Sandoz's wife, sacrifice all for their male geniuses, but seem unable to make anything better by so doing. Not a single female is supplied with a significant creative gift for accomplishing anything beyond managing a household in one way or another or making herself available sexually with at least some

42. Phillip A. Duncan, "The Art of Landscape in Zola's *L'Oeuvre*," *Symposium: A Quarterly Journal in Modern Foreign Literature* 39, no. 3 (1985): 167–76.

degree of originality, enterprise, and imagination. *L'Oeuvre* is arguably the most misogynist of Zola's novels (a fact particularly interesting since it is by consensus judgment his most personal one). The prevailing male impotence threat, already discussed in Chapter 1, constantly finds its mirroring focus (whether sexual or artistic) in the teasing, alluring, at times even affectionate glances of passionately uncontrollable, constantly aroused, multi-orgasmic women. The doings and the very beings of women constitute the routine opposite of and primary opposition to the achievement of artistic masterpieces—or at least this is how Zola presents the situation.[43]

There is an exceptionally provocative and complex elaboration of the "weakening" female theme in Zola's text. The character of Gagnière who exists in Zola's novel for the sole reason of providing a persistent painter/melomane, eventually marries his piano teacher ("a maiden lady who played Wagner to him in the evenings"). He more or less gives up painting his consistently delicate "small" pictures and moves out of Paris to his inherited estate in Melun, returning to Paris only to hear concerts, or on a few "good old days" occasions to have dinner with Sandoz and all the old circle of artists who had been personally close in their youth—the 1860s. When at Sandoz's, Gagnière seems (in the 1870s) increasingly prone to drift from dinner-table conversation toward the piano (conveniently installed in an alcove off the dining room) in Sandoz's first moderately bourgeois apartment. There Gagnière loses himself in picking out Schumann and Wagner passages, oblivious to whether or not he is heard. Zola is presenting him as a sort of lost character, abandoning all for his love of music; but Gag-

43. For Zola on the "question féminine," see Chantal Jennings, "Zola féministe?" *Les Cahiers Naturalistes* 44 (1972): 172–87; idem, *L'Eros et la femme chez Zola: De la chute au paradis retrouvé* (Paris, 1977). Also, Anna Krakowski, *La condition de la femme dans l'Oeuvre d'Emile Zola* (Paris, 1974), esp. 89–90; and France Borel, *Le modèle: Ou l'artiste séduit* (Geneva, 1990), esp. 55–60.

nière is not alone in his fascination at the last of his visits to Sandoz's for dinner (c. 1880?): this time he finds someone to talk to, namely, Mathilde, a former sexually unquenchable, physically deteriorated "friend" of the whole Sandoz circle during the years of her marriage to an aging herbalist. Once loose from that marriage, after the herbalist's death, Mathilde is adopted (presumably because of her uniquely intricate sexual performances) by the reasonably wealthy, successful, totally unprincipled and sexually athletic critic, Jory, who has her teeth and manners repaired, dresses her fashionably, encourages her enthusiastic immersion into the world of concert music, and finally marries her. Gagnière and Mathilde conduct a long, rambling, reverielike dialogue centering on the complex and enthralling character of modern music. Gagnière spouts some philosophy, but together he and Mathilde satisfy themselves trading adjectives about Meyerbeer and Berlioz, but mostly about Beethoven, Schumann, and Wagner.

The Gagnière–Mathilde episode is one of the most intentionally absurd vignettes in Zola's book—old trollop/melomane and painter abandoned to melomania spouting clichéd superlatives about the unique seriousness and depth of modern music's effects. The episode has been cited in the Zola scholarship as *L'Oeuvre*'s low point in terms of plot integration and coherence of style. But it has also been noted that Zola's writing in this episode stands out for its use of broken sentences and missing or partly missing verbs.[44] In fact the episode stands out in both ways, but *why?* Why does the episode exist at all, and why is it so prominent?

As author, Zola seems himself unsure in this episode. On the one hand he plays misogynist with Mathilde. He has Sandoz thinking, "he had often noticed that women could talk music

44. Niess, *Zola, Cézanne, and Manet,* 217, who sees these as the novel's "worst pages."

quite well without knowing the first thing about it" (*L'Oeuvre*, 339). On the other hand, Zola forces his writing to come apart as he describes talk about music, implying perhaps that he recognized music's profound undiscussability. Zola makes music operate "beyond words" by resting it in clichés, but his manner of making it rest there is experimental (if absurd) from a literary point of view in a way Zola almost never is. Clearly there is some sort of fascination/repulsion at work in Zola's text, and I would suggest that it gestures broadly toward the overall effort in the novel to keep painting and writing together rather than to have painting slip into writing-threatening discourse with music.[45] By having Gagnière cease painting as his melomania takes over, Zola makes what seems a very calculated move. He makes the simultaneous activity of melomania and painting mutually exclusive. By doing this he reasserts (almost desperately, one feels) painting's status as a representational art like realist fiction and aesthetically doomed when it attempts to follow any other course. That other course is a conscious blur of music and women.

Zola has one further use for Gagnière and it too introduces aesthetic quagmire. It is Gagnière who voices early on an interest in quasi-scientific theories of color and paint chemistry. His interest is passed on to Claude, whose ill-fated efforts on the great unfinished masterpiece involve much Gagnière-type experimentation with the paint medium and with systematic color application. Even though Zola's treatment of the science issue is threaded through the fictive period of the late 1870s in *L'Oeuvre*, most scholars, quite understandably in the present author's view, feel that Zola was responding to the more recent c. 1884–1885 developments in and around Seurat's and Signac's neo-impressionism. Zola was not alone in viewing

45. Henri Mitterand, "Inscription du temps et de l'espace dans *L'Oeuvre*," in Guieu and Hilton, 151–58.

these developments with some alarm, since the entire genera-
tion of painters he knew best (those emerging in the 1860s)
were in various ways bothered by them. Only Pissarro truly
welcomed them.[46]

However, the particular descriptions of color theory and paint
chemistry that Zola writes into the character of Gagnière are so
generic that one could as well see them as reflecting the informal
debate on such matters that surfaces randomly in the writing on
impressionism from the mid-1870s onward—Edmond Du-
ranty's, for example.[47] The question of the historical "when"
implied by this aspect of Zola's novel is not an unimportant one.
Since science and music fascination are voiced through the same
character, they likely had on some subconscious level at least a
place or period connection in Zola's experience. If that place or
period of this connection was the mid-1870s, when Zola was
much closer to his painter friends than he was in 1885–1886, the
time he wrote L'Oeuvre, then something suggestive of the pri-
vate aesthetic discourse of the 1870s has emerged in his text that
has not been featured since in any straight historical writing on
impressionism for more than half a century. For this alone
L'Oeuvre ought to assume at least a curiosity status in future
writing on the history of impressionism. While not doing so in
any absolutely satisfactory way, the novel does seem to offer
some material infill for the void or voids in the Rewaldian record
of the 1870s. And, not only is material offered, but it is a kind of
material that makes the reopening of critical discourse to the
painting/music issue just after 1880 seem to mark more a pub-
licly voiced culmination of interests, rather than an invention of
those interests from whole cloth.

46. Micheline Hanotelle, "Leo Gausson et Zola (Réflexions relatives à une lettre du
peintre Leo Gausson à Emile Zola et réponse inédite du romancier)," Les Cahiers Natural-
istes 63 (1989): 193–203.

47. La nouvelle Peinture (1876) in Moffett, The New Painting, 477–84 (French) and
37–50 (English).

There is, however, even more to be credited to Zola's novel—admittedly of a less specific sort—viewing it from the perspective of a history of impressionism. The book has, because it was written so close to the period it fictively pictures, a far more comprehensive "period" feel than do any subsequent texts that assemble so-called primary documents and records to produce a period picture at a much later date. In this regard it must be remembered that at least a few writers from the 1890s considered the book a broadly plausible form of historical accounting—fictionalized but plausible (see Herbert, *Impressionism*). Perhaps one should take their word for the situation, particularly because there is so much sensible ("real") coherence to the sights, smells, and sounds that tie the novel together in terms of places, spaces, and the general pace of things felt and done.

Compared to Herbert's recent book, which relies heavily and ingeniously on such things as period travel guides and journals from the period, Zola's book feels alive, with its proportioning based on the experience (admittedly highly personal and self-aggrandizing experience) of living rather than of reading time-insulated texts.[48] Whether they liked the novel or not, Zola's contemporary readers tended to view it as being, at least in part, reliable. The impressionist painters who understandably felt that they had collectively much to lose in terms of reputation and sales from the appearance of the book, could not have felt this way so strongly as they did, had they seen the book as "just fiction." In spite of the already mentioned care Zola took never to speak of impressionist painting by name in the book and never to incorporate the eventful impressionist exhibition history, there was too much that was too identifiably real in his account for the impressionists to derive any comfort from not being "named."[49]

48. See note 32 above.
49. Loevgren, *Genesis of Modernism*, 41–53.

Their discomfort with the book has tended to be viewed from the vantage point of Zola's implied judgment (hardly new to *L'Oeuvre*) of advanced realist painting's failed mission. Loevgren, working from this view, has moved on to consider the book a virtual set-up for a different kind of painting—"symbolist" painting of the Seurat, Gauguin, Van Gogh sort. Without being truly certain of Zola's intention to provide this set-up, Loevgren makes the best possible case for assuming at least partial intention (*Genesis of Modernism,* 41–53). Following Loevgren's argument one is led to conclude that Lantier's masterpiece was doomed, not principally because of its "realist" difficulties, but because it refused to accept demands for antirealism that were ideologically built into the project from the first, and that required pictorial treatment of a totally new sort.

There would be greater temptation to agree with Loevgren and others arguing along similar lines, had Zola himself become a staunch supporter of symbolist art in any medium. But he hadn't, in spite of his cultivating contact with younger writers and contributing at least early on to some of the symbolist journals. Loevgren has, needless to say, documented this contact very thoroughly, and drawn some very strong (arguably overstrong) conclusions from it. What one must ask Loevgren is what was "in it" ideologically for Zola to "project" symbolist practice as a solution to impressionist (realist in his terms) failure, when symbolist practice would proceed (and was proceeding as Zola wrote) to incorporate all of the dangerous distractions Zola had already seen as operating to corrupt his beloved realist practice (at least that practice as it appeared in painting and the spoken or unspoken discourse on painting). Unless one were to argue that Zola was feeding his opposition out of a sense (or condition) of artistic hopelessness—and that is certainly something that might well be argued—the theoretical and aesthetic package that was symbolism has to be seen as standing in absolute contradiction to the theoretical and aesthetic package of *L'Oeuvre*. Melomania,

scientific aesthetic systems, anti-realist forms of image evoca-
tion, archaisms of style, privileged and eloquent impenetrabili-
ties of "meaning"—all this was symbolism, and all of it is pre-
emptively castigated in *L'Oeuvre*.

Returning to Zola's fictionally expressed views on Claude
Lantier's unfinishable painting, it is interesting to see how con-
sistently negative Zola seems to have been about the enterprise
top to bottom. Even while driven by the ambition to create
masterpieces, everything about Claude's way of proceeding was
wrong, but wrong largely because of insufficient certainty and
conviction of method. Claude's prior practice had been too er-
ratic to prepare him intellectually to master the discipline neces-
sary to sustain masterpiece effort where both appearance and
"life" were ideally to coalesce. Yes, there had been quality in
Claude's work, and quality as a penultimate category of achieve-
ment is consistently invoked through Zola's text. But quality
left in small pieces could not be counted on to come together
into a large one. The experience of focused cumulative effort, as
mentioned earlier, was from Zola's viewpoint not there to draw
on when it was most needed.

The great failure—the "monstrousness," the "hideousness,"
the "fetishism" evident in Claude's struggle with his painting
in several forms over several years—involves the progressive
aesthetic back-sliding into romanticism, Zola's consistent ideo-
logical archenemy.[50] Self-indulgence in personal feeling (senti-
mentality), irrational absorption in the quaint and picturesque,
a denial of things as they really are, as they live—this is Zola's
view of romanticism, and it is as negative as it is obsessive. As
already noted, Zola even convicts himself, via Sandoz, of be-
ing unable to be free of romanticism. Yet, compared to how

50. Patrick Brady, "Rococo versus Enlightenment: A View from Naturalism," *Oeu-
vres et Critiques: Revue Internationale d'Etude de la Réception Critique d'Etude des Oeuvres
Littéraires de Langue* 10, no. 1 (1985): 67–72.

Claude is portrayed, Sandoz is much farther along the route to freedom (and truth).

Here it may be useful to return to what has been said regarding the highly problematic and in many ways symbiotic relationship between Zola's description (his fictional invention) of Claude's painting and Manet's *Bar at the Folies Bergère*.[51] In the process of his writing of that painting out of existence because it ought not in his terms to have been able to happen, he showed his aesthetic (and historical) hand most clearly. I have argued that the *Bar* had to be marginalized for the simple reason that Zola could not grant the presence of an aesthetic system sufficiently firm to have supported its production. The painting literally *could not be*, so Claude's failure is established to replace it appropriately as representing how things in advanced realist painting ought to be in all their self-frustrating wrongness. Again, this flags *L'Oeuvre* as a highly complex text that, besides being a Zola novel, is an often infuriating layout of semistraight (roughly factual) history, deployed more or less in reasonable sequence, and "Zola history," which is, of course, "seen through a temperament," at a very particular moment in that temperament's professional and personal life.

It is curious to track the point in the text of *L'Oeuvre* when the masterpiece is thoroughly doomed in principle. The moment when Claude Lantier decides to use a nude woman in the immediate center foreground of the picture marks his surrender to romanticism—a surrender that Manet had definitively *not* made in the *Bar* nor at any other moment of his work. The "unreasonable" introduction of three nude figures, which proved the unfinished masterpiece's terminal unmaking, constituted the key for Zola to the impurity of Claude's aesthetic system and its residually uncontrollable historicism and/or romanticism. That

51. For a discussion of Zola and Manet (and the *Déjeuner* and *Olympia*), see Brady, "Pour une nouvelle orientation," 53–67.

Claude literally will die over his central figure is a virtually fore-gone conclusion to any remotely sensitive reader of Zola's text. It was not so much that Zola objected to the notion of allegory; rather, he objected to something like worn-out allegory, where instead of life there was sentimental convention. Despite the fact that Claude's wife, Christine, selflessly poses in the nude for days on end doesn't suffice to let Zola have Claude's figure come real.

With this as a kind of postscript comes a recapitulation of another theme (or another ideological agenda) already noted in *L'Oeuvre*. For whatever reason the contributive (let alone origi-nal) positive aesthetic role of woman seems to require violent denial at every historical and narrative point, including the novel's conclusion, where Christine's posing just exacerbates a hopeless cause. Women in any form and in any role frustrate the masterpiece in Zola, which causes a modern reader to assume that the masterpiece is and must be (in Zola's terms) an exercise of maleness—powerfully and focally orgasmic, definitive, and capable of moving an ambi-gendered audience with absolutely predictable effect.

I would argue that Zola was signaling a period sensitivity very clearly in his masterpiece/maleness rhetoric. In France in the 1880s and 1890s everybody (at least everybody male) seems to have been obsessed with the time-licensed requirement for a masterpiece performance in every medium. Whether thinking of Van Gogh, Gauguin, Seurat, Mallarmé or Huysmans, Rodin, or Chausson, the masterpiece was a sort of Holy Grail, proba-bly because of a combination of aesthetic circumstances that included the appearance of *L'Oeuvre*, Manet's *Bar,* and Wagner's *Parsifal*. What was the aesthetic alternative to the masterpiece? Perhaps, frighteningly, the "mistresspiece," which was yet to appear as a production of women or of men.

In order to envision the "mistresspiece" (by which I mean only a feminine-gendered version of the masterpiece, and not what might be done by some one or other's mistress), Zola and

L'Oeuvre again become useful. From Zola's parallel fixation on male fear of impotence (or only one orgasm) and female multiorgasmicity, one gets (from Zola's perspective) the sense that the "mistresspiece" would be in some way or other multipartite rather than conclusively focused, based possibly in ensembles or variations on a theme. Perhaps Zola had gotten a foretaste of the "mistresspiece" in mid-1870s realist practice— particularly in Monet's and Degas's work where series begin to appear increasingly, replacing the single-format masterpiece ef- fort. All of this had been immanent in impressionist work after the late 1860s, but the situation really only came to a head in the years just before 1880, and Zola was certainly aware of it. Other- wise he would likely not on so many occasions have faulted his friends for being satisfied with "unfocused" achievement.

Zola would live to see Monet use "series" work to replace more or less completely anything like the singular masterpiece. What Zola thought about this we do not know, since his fresh comments regarding painting effectively cease after the publica- tion of *L'Oeuvre*. Zola would not very likely have noticed Van Gogh's "copies," which raised questions not unrelated to those of Monet's "series." And, of course, Zola did not live to see Paul Klee's streams of small works—arguably *the* "mistresspieces" of the twentieth century. But he did write *L'Oeuvre* and with it left some historical as well as personal tracings that ought not to be disregarded, assuming that a case for their multivalent impor- tance has been made effectively in the above discussion. Whether the answer here is yes or no, the final word on the status of *L'Oeuvre* as history can be safely left to Monet, who wrote a much republished letter to Zola after he had read the book: "I have read *L'Oeuvre* with great pleasure, finding memories on every page." Admittedly this is not all Monet said in that letter, but for present "selfish" purposes, it is the most useful part.[52]

52. Loevgren, *Genesis of Modernism,* 41.

3

La Berceuse—Authored by Music?

There occurs in nature something similar to what happens in Wagner's music, which though played by a big orchestra, is nonetheless intimate.

—Van Gogh to his sister, late March 1889[1]

Before he went away [to Arles] I went a few times with him to a Wagner concert; we both enjoyed it very much.

—Theo van Gogh to his wife, no date[2]

1. Vincent Van Gogh, *The Complete Letters of Vincent Van Gogh* (hereafter cited as *Letters*), with introduction by V. W. van Gogh and Preface by J. van Gogh-Bonger, 3 vols. (London and New York, 1958), III, W3, 431.

2. *Letters,* I, xliii.

At the Universal Exhibition there is a small picture by Manet, which perhaps you saw at Portier's when you were there. It represents a young woman in a white dress, sitting against a background of a little green hill, by her side a carriage with a child in it. The father is sprawled carelessly on the grass behind the woman.

This is decidedly not only one of the most modern pictures, but there is also the highest form of art in it. I am of the opinion that the researcher of symbolism, for instance, need go no farther than that picture, and besides, the symbol is not premeditatedly forced.

—Theo van Gogh to Vincent, 8 December 1889[3]

Today I began again the picture that I had painted of Madame Roulin—the one that because of my accident had remained, for the hands in a vague state. As an arrangement of colors, the reds going to pure oranges, using more in flesh colors as far as the chromes merging into pinks and combining with olive and malachite greens. As an impressionist arrangement of colors, I have never invented anything better.

—Van Gogh to Gauguin, 22 January 1889[4]

3. *Letters,* III, T21, 557.
4. Ronald Pickvance, *Van Gogh in Arles* (New York

I am beginning more and more to try a simple technique which is perhaps not impressionistic. I would like to paint in such a way that everybody, at least if they have open eyes, would see it.
—*Van Gogh to Theo, summer 1888*[5]

Perhaps someday everybody will have neurosis, St. Vitus's Dance, or something else.

But doesn't the antidote exist? In Delacroix, in Berlioz, and Wagner?
—*Van Gogh to Theo, 28 January 1889*[6]

I am reading a book on Wagner which I will send you afterward. What an artist—one like that in painting would be something. It will come.
—*Van Gogh to Theo, 6 June 1888*[7]

The other day I saw for the first time a fragment of Zola's new book L'Oeuvre, *which as you know, appears as a serial in* Le Gil Blas.

5. *Letters*, III, no. 526, 19.
6. *Letters*, III, no. 574; I, 132.
7. *Letters*, II, no. 494, 578.

I think that this novel, if it penetrates the art world somewhat, may do some good. The fragment I read was very striking.
—*Van Gogh to Theo, Antwerp, winter 1885–1886*[8]

Zola creates, but does not hold up a mirror *to things, he* creates wonderfully *but* creates, poeticizes, *that is why it is so beautiful. So much for naturalism and realism, which are still connected with romanticism.*
—*Van Gogh to Theo, Antwerp, winter 1885–1886*[9]

But in Dupré's color there is something of a splendid symphony, complete, studied, manly. *I imagine Beethoven must be something like that . . . that symphony is enormously calculated, and yet simple, and infinitely deep as nature itself.*
—*Van Gogh to Theo, Neunen, 1884*[10]

Read as much Zola as you can; that is good for one, and makes things clear.
—*Van Gogh to Theo, The Hague, 1883*[11]

8. *Letters,* II, no. 444, 471.
9. *Letters,* II, no. 429, 428.
10. *Letters,* II, no. 371, 298; also no. 429, 426.
11. *Letters,* I, no. 219, 421.

*T*n interpreting anything about Van Gogh one works with greater or lesser success in the shadow of his huge corpus of letters where he seems to account for virtually everything he or his art were about, or at least what he thought they were about at the particular moment of writing to one or another of his family and friends. Few artists in any medium have left such a substantial "record" of themselves; certainly no painter, not even Gauguin, has. Rather like Wagner, Van Gogh seems to have wanted to account in writing for everything he felt and believed.[12] Also like Wagner, his feelings and beliefs were highly inconsistent on many issues. A careful study of the writings of either may ultimately yield up as many uncertainties as it does constants. However, either the uncertainties or the constants can conceivably function in interpretation in some fashion if they are clearly labeled as being what they are.

Both Van Gogh and Wagner worked themselves out *for themselves primarily* in their writing. Neither changed his early agenda very remarkably over the years, but emphases shift, depending on factors of mood, audience, and a host of other variables. Both artists were northerners with strong evangelical predilections—quasi-conventional Christian Protestant ones in Van Gogh's instance, quasi-conventional social/aesthetic ones in Wagner. A zeal to "reform," while not systematically utopian in character, marks the writings of both, making them especially problematic as evidence of clear *aesthetic* agendas.

As an interpreter highly suspicious of written documents generally, the present author has much to be suspicious about

12. See especially Richard Wagner, *My Life,* 2 vols. (New York, 1911).

in the employment of Van Gogh's letters (like Wagner's writings) as though they had a true "face value." Admitting that the letters exist *and* as letters, the question that always lurks is, How to use them? Or whether to use them at all? Ultimately they are too large (in type and number) not to be used at all; they must be worked simultaneously with and around in order for interpretation to proceed plausibly and convincingly. How much easier, and arguably more gratifying it is for an art historian of a residually formalist bent to work with Manet or Monet who kept their written records comparatively thin, thereby licensing, even forcing, responsible interpretation in the direction of paintings themselves. What Van Gogh unfortunately accomplished by writing as much as he did was to risk (once the letters were assembled, edited, and published) never again being visible as an incontestably great artist. His aesthetic influence deteriorated in direct proportion to the public (and scholarly) availability of his letters. In exchange he has received massive, posthumous popular worship. His bright, simple images decorate (via reproductions) rooms all over the world. The prices paid for his originals routinely erect new ceilings to blow through.

With his letters Van Gogh made himself (in appearance at least) too readily understandable. He gave up by so doing being seriously understood at all. When there is no friction between public and scholarly aesthetic recognition, this is, it seems, the inevitable result. Scholars are never more comfortable with the public and vice versa than they are when the subject is Van Gogh. There should be some fairly clear warning signals visible to all parties in this situation. If the great is always residually a bit difficult, the absence of difficulty means one of two things: either what is being considered is not great, or its true greatness is not being confronted. I would argue for the latter in the instance of Van Gogh's best work, as in that of any truly original artist.

What is Van Gogh's best work? As with any master there is not one but many, yet a few stand out in one's experience, not because one "likes" them in an everyday sense, but rather because they are, for one reason or another, unable to be forgotten or even put into pleasurable experiential storage. *La Berceuse* is number one in the latter category for the present author, and for reasons that will be explored further below, it may well have been Van Gogh's own "he could hardly believe he'd done it" painting as well. No other painting was talked about more by Van Gogh in his letters after it was finished,[13] and few of the artist's major works seem to have happened with such surprise of effect—an effect he could never totally account for no matter how hard he tried, or how many times to however many people. No other painting was copied (five times) so frequently and no other was thought about in terms of display so carefully. Yes, there were lots of *Sunflowers* produced, but they form a garden while *La Berceuse* is a moment in and to itself. A mistresspiece/masterpiece issue? Probably, but not discussable in those terms at this point.

As with Manet's *Bar, La Berceuse* has a long life in the present author's experience. I saw the Boston version even before having committed absolutely to a career of teaching and writing art history. As a graduate student, I visited the painting on a virtually weekly basis (always alone) for nearly three years, and after that managed at one time or another to see most of the other versions and to spend at least some time with them, but the Boston picture, simply because of who I am and where I have lived, is "my" *Berceuse*. That it seems the *Ur-Berceuse* to me is probably suspect. I just know it best, and have never had an opportunity to see all of the *Berceuses* together (and there probably never will be, if museum directors around the world hold to

13. The most important discussions are in *Letters*, III, no. 574, 129; no. 575, 132; no. 576, 133.

their well-founded fear of highly focused terrorist assaults). Better that the *Berceuses* stay separated. The world needs all the *Berceuses* it can get—again a sentiment with which Van Gogh would likely have agreed.

I have just coupled *La Berceuse* with Manet's *Bar* in a description of my own professional viewing life. This has been done consciously, because I feel that somewhere underneath all the apparent differences between the two images, they have much in common, beyond their relative proximity of date. Venturi cannot, unfortunately, be called upon to help with explanations here. *La Berceuse* was not on his short list of Van Gogh masterpieces, for whatever reason.[14] That aside I must return to Venturi's characterization of the *Bar* as "phantasmagoria" (*Impressionists,* 25) to coin the term "apparition" to name preliminarily my own sense of *La Berceuse*. Obviously the two terms, while different, have something in common. Surprise without resolution, but with some form of cadence, is implied by both terms. In describing the terms, I have to wonder retrospectively whether or not *La Berceuse* (which I knew first) and my response to *it* conditioned (along with other things such as "texts," already mentioned) later responses to the *Bar*. Somewhere deep inside me there is a desire for such to be the case. Nothing could reassure me more in what I do as an "interpreter" of paintings than to have my experience of the great ones resonate in some way with what I say or write about them!

Personal needs aside, why do I insist on calling my experience of *La Berceuse* apparitional? The only answer, or the only simple answer, is that this term best describes my cumulative sensations of the painting. Like the *Bar*, I find *La Berceuse* frightening and reassuring, violent and gentle, raucous and decorative. In addition, it seems audibly very loud and very soft, absolutely

14. *Impressionists and Symbolists,* trans. Francis Steegmuller (New York, 1950), 192–95.

discordant and absolutely resolved. Since it is a *Berceuse,* am I not entitled, perhaps even required, to listen as well as to look?[15] The question of whether or not *La Berceuse* seems an impressionist painting or something else is difficult to answer. Van Gogh thought it was, and in part he was probably right, assuming impressionism is defined, as it never really is, in his terms.[16]

What in fact was impressionism or an impressionist picture to Van Gogh? The answer is that it was (after 1886) a generically modern French painting. It could be a Manet, a Monet, a Renoir, a Pissarro, a Seurat, or a Gauguin. It could be anything that used the full spectrum palette to evoke emotion through the arrangement of oppositions and harmonies of high-keyed color, the use of drawing to inflect such, and the enterprise of the whole pictorial operation geared toward the expression of something like "feeling." From a post-Shiffian perspective, it is relatively simple now to assume all of this as continuous impressionist/postimpressionist (symbolist) currency, downplaying the traditional distinctions between the recording and inventing operations of imaging.[17] But there are a few hesitations that need to be entered in order to accept Shiffian seamlessness.

To begin with, no post-1887 Van Gogh looks very much like a pre-1883 Monet—a post-1883 Monet, yes, perhaps. Van Goghs, *La Berceuse* included, look more like Gauguins broadly speaking, but one could never mistake one for another. The problems have to do with emphasis, which can be named a pictorial form of rhetoric. The color practices of mid-1870s

15. George Mauner, one of the generously attentive readers of this book in manuscript form, suggests that my interpretation of *La Berceuse,* as signaling a musical form exclusively, ignores the possibility that the French construction can mean as well the one who rocks the cradle. I suspect that Van Gogh anticipates the double reading.

16. Pickvance, *Van Gogh in Arles,* 246–47.

17. *Cézanne and the End of Impressionism—A Study of the Theory, Technique and Critical Evaluation of Modern Art* (Chicago, 1984), 55–70.

impressionism may continue into the advanced work of the 1880s, but they don't continue in anything like the same way or with anything like the same expressive effect. In my own, admittedly rather slick, undergraduate teaching terms, there is a shift in color functioning from expressing the "feeling of seeing" to the "seeing of feeling." Adequacy of terms aside, the shift is a major one and not to be denied by continuities of palette and recurrent personalisms of paint stroke. The impressionist language may be constant, but what is being spoken with it is radically different. Perhaps impressionism's greatest legacy was its refusal to bond a pictorial language (color/touch operations) to fixed style. What Zola saw as being inconclusive was in fact liberating in a way no past pictorial style had ever been. Impressionism offered only its accomplishments; it did not demand the order of their reception or subsequent use. It is doubtful whether any artist (with the possible exception of Redon) felt the realness of the impressionist gift so profoundly as Van Gogh, or made better and more original use of it.

Van Gogh's entrance into the impressionist scene was fortuitous. And, the entrance had been prepared in a unique (and largely nonreconstructable) fashion by his brother, who had all the day-to-day, year-by-year experience of modern French developments Vincent lacked. Extrapolating from what Van Gogh suggests in his pre-Paris letters, it seems that he had heard a good deal about Manet, and something less comprehensive about the impressionists. He had, so far as one can determine, heard nothing specific about the neo-impressionists. He had access to some French periodicals in Antwerp in 1885, and it was there that he read *L'Oeuvre*. Interestingly, he assumed that *L'Oeuvre*'s chief character, Claude Lantier, was based exclusively on Manet, and it seems that his brother said nothing in return correspondence to contradict this notion (*Letters,* II, no. 452, 494). What also seems clear is that Van Gogh had never in fact experienced modern concert music prior to his arrival in Paris (*Letters,* II, no. 371,

298). Clearly his brother mentioned it in correspondence, but Van Gogh himself could only imagine what it was like. While he may have seen some impressionist-type painting in Antwerp or possibly Brussels, Van Gogh does not indicate it in his letters in any way that makes the case conclusive.

Yet, Van Gogh's paper knowledge of impressionist art did not in any sense seem to retard his own pre-Paris progress as a modern painter in training. He felt sufficiently confident of his own up-to-dateness to send his brother a still-life of his own in response to the latter's description of a Manet (*Letters,* II, no. 429, 429). By the time Van Gogh got to Paris, he was a good deal more than just a technically proficient painting student. What gave him the confidence to send his still-life to his brother was that he had familiarized himself with the ideological issues of French modern work; perhaps more important, he had become himself an accomplished draftsman and handler of paint. Practice and the careful study of drawing manuals had helped him with the former, and concentrated study of the northern masters, particularly Rembrandt and Hals, had assisted with the latter.

What Van Gogh saw when he arrived in Paris was a kind of modern painting about which he had already heard a good deal. There must have been some surprises particular to 1886–1887 (largely due to Seurat), but Van Gogh was certainly well prepared for what he saw, and technically able to make rapid and efficient use of it. As his Paris works indicate, he adapted his technique quickly and effectively to the extended chromatic meanderings of mid-1880s impressionism. The typical complementary contrasts, generic harmonies and dissonances, appear in Van Gogh's work almost immediately, as do the reduced scale and nervousness of the typical impressionist brushstroke— Monet's and Pissarro's. What also appears that is particularly significant and absolutely a function of the timing of Van Gogh's entrance, is the amount of clear drawing that remains in

his work to accompany this exercise of the impressionist palette and of the impressionist *facture*.

From post-Paris letters (Van Gogh didn't much need the mail in Paris as he saw his brother more or less constantly), it is obvious that Renoir's "clear line" was perceived as a natural part of impressionism (*Letters,* II, no. 481, 556). This is not a perception Van Gogh could have had, had he arrived in Paris much before 1886. Similarly, the choice between regularity or irregularity of paint stroke was absolutely open in 1886, thanks to the powerfully demonstrated alternatives posed by Monet and Seurat. The rapidity of Van Gogh's assimilation of mid-1880s modern pictorial conditions has been remarked on so often as to require no further elaboration here, but what does perhaps need to be reemphasized is the fact that he was very well prepared technically and aesthetically for what he saw.

He may have been less ready for what he heard. Van Gogh's brother seems to have used the Paris years to bring the artist thoroughly up-to-date in terms of hearing as well as seeing—the two activities having become increasingly complementary parts of the modern French aesthetic experience.[18] Whatever the number of concerts attended and whatever their programs, Van Gogh left Paris an absolutely informed modern melomane, both able and enthusiastic to cross-reference pictorial and musical effects. And this the behavior of someone who may not have known anything more than words *about* modern music before 1886! If nothing else, Van Gogh's instant assimilation of pictorial and musical discourse in Paris indicates the pervasiveness of that discourse by 1886, exactly the period of the most extensive outpouring of writing about Wagner, both in the *Revue Wagnérienne* and

18. H. R. Rookmaker, *Synthetist Art Theories—The Genesis and Nature of the Ideas on Art of Gauguin and His Circle* (Amsterdam, 1959), esp. 114–50. See also Sven Loevgren, *The Genesis of Modernism: Seurat, Gauguin, Van Gogh, and French Symbolism in the 1880s,* rev. ed. (Bloomington, Ind., 1971), 16, 25, 27, 61, 83, 85, 87, 92–93, 123, and 191.

in major biographies such as Julien's[19] and an updated version of Schuré's (updated to include *Parsifal*).[20] Arriving when he did, Van Gogh caught the impressionist/Wagnerist/early symbolist aesthetic smear at its thickest.

Prior to 1887, Van Gogh had been in a sense the "perfect" reader of Zola's *L'Oeuvre,* largely because (a) he was an avid Zola fan and (b) because he was a marginally well-informed outsider in terms of the history of impressionist painting. Once he became a *very* well-informed insider, his respect for Zola's book lessened considerably.[21] Obviously its ideological maneuverings became transparent once Van Gogh saw what there was to see, heard what there was to hear, listened to and read the quickly maturing symbolist aesthetic line. But while he would find Zola deficient in his comprehension of truly modern painting, Van Gogh never lost his respect for Zola's overall literary mission. And, to the end of his life, Van Gogh would emulate Zola's passion for presenting the spectacle of life (gloriously or ungloriously) as it is.[22] However, Zola's aesthetic prescripts for managing this pictorially were not after 1887 given much credence by Van Gogh. The real excitement (a composite rather than a singular aesthetic package) of modern French painting seemed ultimately more suited than Zola's fictional account to the working out of Van Gogh's personal ambitions.

However, it was not until he left for the south of France, settling finally in Arles, that Van Gogh managed to establish a sufficient perspective on Parisian developments to begin his own personal

19. Adolph Jullien, *Richard Wagner: Sa vie et ses oeuvres* (Paris, 1886). For complete listing of all major writings in French treating Wagner before 1902, see Henri Silège, *Bibliographie wagnérienne française* (Paris, 1902).

20. Schuré, *Le Drame Musical,* 2 vols. (1876; Paris, 1886).

21. *Letters,* III, no. 543, 58; also II, no. 418, 399 and III, R38, 391.

22. *Letters,* III, no. 597, 188; W1, 426. For typical views see *Letters,* II, no. 451 and III, W3, 430.

maneuverings within them. Both before, during, and after Gauguin's visit in the fall of 1888, Van Gogh seems, judging by his paintings more than his letters, to have accomplished a pictorial rhetoric thoroughly his own. While continuing to be highly reactive to the memory of things seen, heard, and read in Paris—things constantly updated via correspondence from his brother, Gauguin, and Emile Bernard particularly—Van Gogh nonetheless worked out a course of his own. Sometimes that course looks more or less purely pictorial; at other times it appears comparatively laden with something like a preconceived literary or musical program.

Paintings like the artist's *Bedroom in Arles, The Night Café,* and finally *The Starry Night* are paradigmatic of the "preconceived" Van Gogh. His numerous canvases of *Sunflowers* are equally paradigmatic of the "pictorial." And, interestingly in this regard, only the *Sunflowers* are, when they are begun, described in letters as deriving from a particular, purely pictorial inspiration securely stored in Van Gogh's, and presumably his brother's, memory. While other works from Arles may be and often are described with passing reference (analogy-type reference) to particular paintings known and remembered, only the *Sunflowers* truly derive from a single prototype, a Manet still-life of flowers, which seems to have been one of comparatively few genuine Manets that Van Gogh had actually seen in Paris (*Letters,* III, no. 527, 20). For reasons that will be proposed below, Van Gogh would ultimately envision displaying his *Berceuse* as a triptych, using sunflowers as the wing panels (*Letters,* III, no. 574, 129). What may be appropriately suggested here is that Van Gogh rightly realized the subject neutrality of the sunflowers and consequently could see them operating as a purely visual reinforcement to an image of a much more subjectively elaborate type. The prospect of showing work with the Société des Vingt in Brussels in a context known for its encouragement of artist-dictated complementary

hanging, rather than random groupings of work by size or subject, may well have figured in his triptych programming of *La Berceuse* with *Sunflowers*. It is tempting to suggest, as well, an obvious reinforcement to this notion. Given a potential Belgian venue, Van Gogh was likely paying tribute to the triptych form so long associated with the Catholic north of Rubens, among many only slightly less illustrious others. Van Gogh had read Fromentin's *Maîtres d'autrefois* in Antwerp, so, Dutch Protestant or not, he was well-programmed to execute an association between himself and Rubens as preeminent "northern" religious painters (*Letters,* II, no. 371, 294).

Turning specifically to *La Berceuse,* we must consider a few obvious points before problematizing the picture overmuch. To begin with, the portrait is the conclusion of a group of portraits of the family of the postal clerk, Roulin—perhaps the nearest thing to a dependable group of generally indulgent friends Van Gogh developed in Arles over the period (under two years) of his medically difficult residence, either there or at the nearby asylum of Saint-Rémy de Provence. It is the current scholarly convention to see *La Berceuse* as part of this group, yet (because Van Gogh made so much of it) something special within it.[23] But there is a good argument for placing the picture in a broader context as well, the context of Van Gogh's portraits, first of families, and second of women.

From Manet (or better, from the reputation of Manet), Van Gogh had seen the "woman" as a major modern challenge for pictorial accounting. Ignoring for the moment Van Gogh's own chronically difficult relationships with women (excluding his sister?) which cannot, art-historically speaking, be a particularly secure ambience of interesting conjecture, the artist had as early

23. Pickvance, *Van Gogh in Arles,* 246. For the best summary of the state of the question here, see Haruro Arikawa, "'La Berceuse': An Interpretation of Vincent Van Gogh's Portraits," *Annual Bulletin of the National Museums of Western Art* [Tokyo] 15 (1981): 31–75.

as December 1885 reacted in writing to the infinite beauty of the analysis of women by the very great men of modern literature, Zola, Daudet, de Goncourt, Balzac.[24] As regards families, Van Gogh had attempted his first "masterpiece" (although he would have been too modest to call it such) in the *Potato Eaters* of 1885. There, a working-class family meal of the very poorest sort encouraged Van Gogh's first attempt at ambitious, carefully prepared (technically) and carefully conceived (intellectually) picture making in the broadest sense.

There are strong and distinct forward resonances (probably unrecognized by the artist himself) from the specific project of the *Potato Eaters* and the encompassing challenge of the portrayal of "woman" to *La Berceuse*. With the exception of the rendering of the face (which has a strange, residually photographic aspect underneath its high-pitched yellow-orange coloration) the drawing throughout *La Berceuse,* both in the figure and in the setting, has a quality very reminiscent of the comparably feigned lack of graphic sophistication that pervades the *Potato Eaters*. In both paintings it seems as though Van Gogh were undertaking to merge his representation and his manner of representing into a pictorial structure of "commonness." The schematic clumsiness of the *image d'Epinal* and the cheap chromolithograph drive Van Gogh's development of the image in both paintings. The color, too, has a broadly zoned aspect overall, something that markedly increases the fictive printed look of the image, or at least the shape matrix of the image. What appears of Van Gogh's "painting" lies in a structure of brushmarkings that seem to stand literally on top of the colored shape matrix. It is as though he is painting over, or retouching something preexistent—a practice suggesting the hand tinting of a black-and-white print or the retouching of a colored one.

The process of feigning a sort of folk-art look in *La Berceuse* is

24. *Letters,* II, no. 442, 466; also no. 444, 470; no. 482, 599.

understandably far more sophisticated there than in the *Potato Eaters,* largely because Van Gogh's experience with modern painting practice had expanded enormously over the intervening years. He had more ways of feigning simplicity, and in *La Berceuse* he mustered virtually all of them. He had studied Japanese prints (even making a painted version of one). He had "learned" impressionist and neo-impressionist practice inside and out, and most important, of course, for *La Berceuse,* he had the example of Gauguin's and Bernard's work clearly in his mind.

La Berceuse was, it must be recalled, begun during the last weeks of Gauguin's residence with Van Gogh in Arles. As a conception driven strongly by the effect of Gauguin's presence— a presence that virtually all scholars of Van Gogh recognize as having exerted immense psychological and aesthetic pressure on Van Gogh—*La Berceuse* has an explosive quality overall that at first seems to stand in total opposition to its apparent simplicity and directness. The wild dance of the wallpaper where flowers and stems and leaf forms refuse to settle into the order of printed repeats is only one of many explosive features, but it is *very* explosive; seen as fictive background it appears either to be coming apart where it is, or, alternatively, to be moving forward and refusing to remain background.[25] Similarly, in Van Gogh's broadly stroked brushmark clusters (usually rhythmical internally) there is an equally explosive, expressively genuine, or feigned foregrounding of a very obvious form of fetishism. The brushmarks read like the painter's hands, clumsily fondling the key surfaces of the skirt and the breasts; more delicately touching the hands, the face, and the hair. Strangely, though, the pictorial effect of this touching/fondling is to pull the image forward

25. A. Myerson, "Van Gogh and the School of Pont Aven," *Konsthistorick Tidskrift* 3, no. 4 (1946): 56ff. See also Mark Roskill, *Van Gogh, Gauguin, and the Impressionist Circle* (Greenwich, Conn., 1970). I received my first in-depth exposure to this material in a Roskill seminar at Harvard University (1962–1963).

toward the spectator, rather than to press it (as touch normally does) back. Van Gogh's touching/fondling seems to arouse a miraculous plastic life of its own as it moves from point to point in the image.

The effect of the persistent tactile activity of Van Gogh's paint structure is to induce very strong sensations of an incipiently three-dimensional presence. By touching he makes something touchable come into being, or very nearly so. As a "decorative arrangement" Van Gogh relies in *La Berceuse* almost totally on shaped color relationships that, as he devises them, vibrate laterally in persistent and intense forms of complementary contrast. Variations of red versus green are most prominent and form the "dominant" coloristic/decorative chord. Throughout the picture, drawing (or the marking of edges) is bold of accent and broad physically, so that it works with the color chords to flatten the image.

However, a high degree of visual friction develops between the flattening operations of contrasting colors, the surface adherent quality of drawing, and the plastic counter-assertions of Van Gogh's fondling touch. *La Berceuse* comes into its very special form of life as the spectator engages the friction visually *and* psychologically. The sense of being rocked (or simply rattled) passes into the psyche straight from the eyes. The cradle rope stands as a material afterthought, pictorially useful but psychologically redundant to the painting's delivery of its effect.[26]

The "frictional" stresses vary, sometimes slightly, sometimes considerably, from one copy of *La Berceuse* to another. Whether intending to do so or not, Van Gogh subtly alters the mood of the image through the group, not progressively or systemati-

26. See Arikawa, "'La Berceuse,'" 57–58. Arikawa has an interesting "engineering" notion that the unattached cradle rope is actually, because of the intended destination of the picture, rocking or being rocked by a literal boat.

cally, but remarkably. We know that Van Gogh insisted he was making copies as he produced his successive *Berceuses*. What we don't really know is what he in fact meant by insisting as he did. Was he asserting that all were equally "good" and therefore identical in aesthetic quality? Was he suggesting that the visual and psychological life was constant throughout the group? Was he glossing over his "inability" in part to execute a true copy (whatever that would be)? I would argue that Van Gogh knew he had stayed with and in the picture as its feeling-maker throughout the production of the "copies." I mean by this that he never truly stopped painting *La Berceuse*. As he moved from canvas to canvas, even over considerable layers of time, he was never finished with it until he had reached a point where to go on would have meant making a nonoriginal or a conventional copy. Since the picture had been born interrupted, so to speak— it was unfinished on Van Gogh's easel for the several weeks of his first breakdown—it had a history of being able to be taken up again. The copies continue this history as long as original feeling holds for the artist. Up to a point, doing *La Berceuses* was not unlike doing *Sunflowers,* but only up to a point. Van Gogh kept real sunflowers around to pose while he painted them. With *La Berceuse* he had, after the first, only one or more *Berceuses* to work from.

This fact may also bear on why Van Gogh insisted that all but one *La Berceuse* were copies. He was being honest in a very literal sense in declaring that what is done from painting is a copy, while what is done from nature is not. Leaving aside the few paintings Van Gogh invented from memory (*The Starry Night,* for example), the "from nature versus not from nature" classification is reasonably persistent in Van Gogh's characterization of what he was doing from 1886 in Paris to 1890 in Auvers. The "from nature or from memory" issue as one of practice had peaked during the period of Gauguin's stay with

Van Gogh in Arles, apparently sparking often quite heated debates.[27] Van Gogh's attempt to realize his own pro-nature position in these debates with Gauguin's anti-nature one may well have been part of the *Berceuse* program at its inception in Gauguin's presence (and its completion and copying in his absence). Whatever the case, the painting ultimately became both from and not from nature. And, judging from Van Gogh's possibly reliable later description of the conception of the work, there appears from the first to have been an elaborate strategy in place to assure the "from nature and not from nature" aspect of the project.

In an ingenious and rather elaborate way, Van Gogh fictively set out to deny his authorship of *La Berceuse*. He did this, we are told, by positing a fictive maker. Much has been written about the original program of *La Berceuse,* its relation to Gauguin's merchant sailor past and to Pierre Loti's *Pêcheur d'Island,* a story which attracted Van Gogh very considerably when it appeared in 1886 (*Letters,* III, no. 574, 129). The substance of Gauguin's sailor persona and Loti's text appear to have come together in Van Gogh's mind to form around *La Berceuse* the notion "to make a picture such as a sailor at sea who could not paint would imagine to himself when he thinks of his wife on shore."[28] In other words, Van Gogh set himself—a highly sophisticated painter—in the fictive position of not knowing how to paint at all in order to produce the perfect "cabin furnishing" for a sailor away from home for long periods and out of touch with his emotional/sexual moorings. Did Van Gogh intend by this strategy of disdaining skilled making to penetrate some depth of being greater or more difficult than he had ever experienced himself? The question is impossible to answer, but the strange-

27. *Letters,* III, esp. no. 562, 105 and no. 563, 106.
28. *Letters,* III, no. 574, 129; on Gauguin and Bernard "painting like children," see *Letters,* no. 527, 20.

ness of the feelings imagined probably explain at least in part the durability of the *Berceuse* project.

Placing himself outside himself in order to feel new and original feelings—this is the personal fiction of *La Berceuse*. It is a fiction that gave the image such a prolonged life in Van Gogh's work. Not being the "real" imaginer, he could quite literally imagine any feelings he wanted around a rather loose theme involving absence from wife/home or whatever. He had a perfect Zolaesque opportunity not just to mirror, but to create. And create he did—five times! From one *La Berceuse* to the next there are substantial shifts in pictorial and resultant image feeling. Some versions are close, others remote. Some are comparatively hieratic, others physically and psychologically more approachable. Without changing any of the basic terms of the picture's construction Van Gogh manages (for this spectator at least) to probe nearly every emotional variable the image could be imagined to elicit. By thinking (and personally feeling) that he was expressing in the third person, Van Gogh probed in *La Berceuse* more deeply and with less fear into depths of personal emotional experience that never were let surface in his other work in comparably direct and elaborate ways.

He did not, however, create a modern "Madonna" in *La Berceuse*. Even though the truffle-sniffing iconologists of Van Gogh studies have argued the question for many years, it seems literally misguided simply on the basis of Van Gogh's images themselves.[29] To call the painting a modern "Madonna" denies the fact of the artist's well-executed strategy of originality in the image. Simply put, if Van Gogh had wanted to do a Madonna, he would have found a far simpler way of doing it; or he would have worked from any number of historical Madonnas he knew well. Here it is important to remember how many of Delacroix's works Van Gogh "copied" or did over in his own way in

29. See Arikawa, "'La Berceuse,'" 46–58.

1889. When he intended a conventionally religious image, he had his exemplars clearly in place, so at the risk of running against a considerable body of Van Gogh scholarship I will have to say quite simply that *La Berceuse* is not a modern Madonna; rather, it is an original *Berceuse*. That is what the painting is labeled within itself in the lower right corner of most versions and that is what it is.

But what does it mean for a painting to be an original *Berceuse?* In a certain sense it means not being a painting at all, but rather a piece of music. A *berceuse* is, after all, a lullaby—a song of rest. It suggests no special breed of religious abstraction, but a down-to-earth sensation of consolation. Rather than keying into an iconographic tradition, Van Gogh managed in *La Berceuse* to initiate one. He got the "Madonna" baggage out of the way and made an *Andachtsbild* completely his own. Like Manet's radically reconfigured Magdalen in the *Bar,* Van Gogh's *Berceuse* has only the most distant relation to an art-historical prototype.

How fundamentally boring it is in fact to read about all the variants of proposed madonna-ness in *La Berceuse* in the scholarly and the popular Van Gogh literature. Everything looks backward to the past, not to the present and future. In and around *La Berceuse,* Van Gogh was thinking a good deal of the emotional reassurance offered by Wagner's and Berlioz's music; he does not seem to have been thinking much, if at all, about Raphael, or even Delacroix or Rembrandt for a moment. Instead he was devising an emotional, even spiritual, *original,* and then producing the first elaborations or variations on that original. But an original what? Like the late medieval Pietà, Van Gogh's *La Berceuse* deployed mother/lover feelings of the most personal sort in a distinctive way.[30] But France in 1889 was not the medieval Low Countries, and no cults and/or religious practices could be expected to form around the new image. With

30. See J. E. Ziegler, *Sculpture of Compassion* (Brussels and Rome, 1992).

God "dead" and art-making an increasingly more individualized enterprise, Van Gogh had to rely on himself both to invent and then to elaborate upon what he had invented. No one after him would do it for him. His run of the theme of *La Berceuse* would be the only one. The extended life of the image, which was a modern, hence individual one, was his to explore and his alone.

But to return to the question of "true" authorship in the instance of *La Berceuse,* it is of course self-evident that Van Gogh painted all the copies of *La Berceuse,* in spite of his fictive self-removal as author in favor of someone—a fisherman—who could not paint. There is something else besides *that fisherman* that Van Gogh introduces to account for the existence of the painting. That something else is, or signed itself as being, "La Berceuse." The signature, or what I am calling the signature, appears in the customary position of painters' signatures, in the lower right red area of most *Berceuses*.[31] Without breaking into the red area with an inscribed signature, Van Gogh simply inscribes "La Berceuse" into the wet red paint, so that redness, painting title, and a strange suggestion of implied authorial identity all merge.

What would it mean for a painting entitled *La Berceuse* to be painted by "La Berceuse"? The answer is as simple as it is enigmatic. Van Gogh suggests a form of music authoring a "musical" painting—both notions encompassed by the naming "La Berceuse." Is one to assume that Van Gogh's painter couldn't paint, yet painted; couldn't sing, yet sang? I would argue that this is precisely what the inscription suggests in its seemingly innocent "finger-painted" way. The artist wanted musical sensation, did everything he could graphically, coloristically, and imagistically to manage it, and signed the picture in such a way as to suggest what he had wanted. Whether he got what he wanted is another question. Can *La Berceuse* be

31. For Van Gogh's sensitivity to "signature" at this time, see *Letters,* III, no. 524, 17.

heard? Does the synaesthesia implied truly function? The answer here lies in the spectator. Van Gogh clearly did everything he could imagine to generate an audible sight. Insofar as any artist has managed to achieve the simultaneous effect, Van Gogh probably succeeds. Music, at least conceivably, authors, organizes, and controls a vision.

Postscript

While it might be interesting to probe issues of spectatorship in the instance of *La Berceuse* in a gender-specific fashion, the proper route for doing so is not absolutely clear to the present author. It is virtually impossible to say with certainty that Van Gogh as a male saw his spectating audience in male or male-dominant terms. He never seems to make many adjustments, except practical ones, in his discourse when writing to his brother or sister, but that observation hardly helps much in answering the question whether or not the performance of *La Berceuse* is gender-unspecific. True scholar/devotees of Freud or Lacan could probably (after a certain amount of head-scratching) establish some conditions for naming Van Gogh's touching/fondling operations as being readable either as gender-encoded or not. Ultimately the consensus decision might be that the image is at once too simple and too opaque to render any psychoanalytic discussion useful at all. A modern anthropologist might analyze with some profit the culturally symptomatic as opposed to the "original" aspects of Van Gogh's invention of both *La Berceuse* and its inventor, also "La Berceuse." Antireligious religiosity is inarguably a significant part of *La Berceuse* as it is in much ambitious image-making (and cultural behavior generally) in France in the 1880s and 1890s.

The present writer, being an art historian, is not equipped in

depth to pursue responsibly alternative modes of reading *La Berceuse* (or any other aesthetically complex painting) that require standing too far outside the activity of looking. The picture must stay clearly in view for art-historical discourse to carry any weight of an intellectually challenging sort. This does not mean that other paintings may not or need not be introduced in order to elaborate upon interpretation. Rather, what is being suggested is that for an art historian the most telling evidence about what is clearly visible is necessarily referenced and cross-referenced by that which can be pointed to and seen not once, but many times, with the same visual evidence often suggesting shades of reinterpretation depending upon the time, place, or other conditions of viewing. Certainty, at least for a moment, is the best one can hope for in interpreting the truly great painted enigmas of which *La Berceuse* is one (or rather five).

In this study the painting has so far been approached historically from behind—from the vantage point of the *Potato Eaters*. Other studies have and will no doubt continue to approach it in a more strictly contemporary context, stressing more forcefully the visible aesthetic pressures of the Pont-Aven circle, of neo-impressionism and of the theoretical debates of symbolism so active in the Parisian small circulation press.[32] I have no doubt that a fair number of potentially plausible interpretations of *La Berceuse* remain to be advanced by considering in depth the contemporary sociopolitical ambience, but I also suspect that when these are provided, they will in various ways tend to reinforce what I have proposed "from behind" and what I am about to suggest by looking ahead a few months in Van Gogh's work.

The issue of the copy neither began nor ended for Van Gogh in *La Berceuse*. He had copied his work before (never so many times)

32. This is essentially the Loevgren–Rookmaker–Roskill tradition of discourse following Rewald.

and he would do so again (but never so many times). By virtue of the act of copying having transmuted into such a uniquely creative routine in *La Berceuse,* there appears to have developed in Van Gogh's mind a belief or at least a suspicion that one might profitably create by copying, just as one could create by working from an original motif. This is a suspicion he tests, producing some surprising results during the period marked by his residence in the hospital at Saint-Rémy. While making rather pro-forma complaints to his brother about not having models available at the hospital or just feeling poorly, Van Gogh actually appears (in writing at least) to have become quite enthusiastic about making copies of favorite images by favorite old masters—Millet, Delacroix, and Rembrandt among others.[33] He produced twenty-one copies after Millet alone at Saint-Rémy.[34] To his brother he writes, "We painters are always asked to *compose* ourselves and *be nothing but composers.*"

> So be it—but it isn't like that in music—and if some person or other plays Beethoven, he adds his personal interpretation—in music and more especially in singing—the interpretation of a composer is something, and it is not a hard and fast rule that only the composer should play his own composition.
>
> Very good—and I, mostly because I am ill at present, I am trying to do something to console myself for my own pleasure.
>
> I let the black and white by Delacroix or Millet or something made after their work pose for me as a subject.
>
> And then I improvise color on it, not you understand, altogether myself, but searching for memories of their

33. Ronald Pickvance, *Van Gogh in Saint-Rémy and Auvers* (New York, 1986), 155–58.
34. Ibid., 155.

pictures—but the memory, "the vague consonance of colors which are at least right in feeling" that is my own interpretation.

Many people do not copy, many others do—I started on it accidentally, and I find that it teaches me things, and above all it sometimes gives me consolation. And then my brush goes between my fingers as a bow would on the violin, and absolutely for my own pleasure.[35]

Without granting that one should take what any artist says without requisite caution—Van Gogh is notably defensive in much of his writing of the Saint-Rémy period—there are some terms floated in this letter that resonate with much that has already been advanced in this chapter regarding *La Berceuse,* the copy, and other issues; there is thus at least some temptation for considering seriously what Van Gogh undertook to say in this particular context. Copying, he felt, was like musical interpretation and therefore something original in and of itself—or at least ideally so. Additionally it is a "consoling" activity, and consolation is a term Van Gogh persistently attaches to the experience of listening to music. Finally, it is color that the painter improvises and interprets (performs) with when she copies, and the activity of taking up the brush to interpret (copy) is likened to picking up a bow to play a violin. Copying as reevocative, creative rather than just re-creative: this seems to be the essential theoretical position Van Gogh is trying to establish. And above all its operations and results are closely bonded to music.

When Van Gogh suggests that he started copying by accident, one becomes reasonably suspicious of his reliability (historically speaking) as a narrator. But perhaps one shouldn't be. Perhaps

35. Ibid. See also *Letters,* III, no. 528, 21: "Painting as it now promises to become more subtle—more like music and less like sculpture—and above all it promises *color.* If only it keeps this promise." (late August? 1888).

that "accident" was *La Berceuse* or the *Les Berceuses*. Sensing how good it felt to copy/interpret himself, Van Gogh selfishly tried to rekindle that good feeling at a time when he felt he most needed something to feel good with. He needed to sing to himself—lullabies, one presumes—and to have the pictures sing back, which the copies do most eloquently and with much original feeling.

4

Monet and the Embrace of the Series

Decentralized "Masterpiece" or the Aesthetic Multiple Orgasm?

In this small and limited exhibition at Gurlitt's, the formula is clearest in Monet . . . and Pissarro . . . where every-thing is obtained by means of a thousand small touches, dancing off in all directions like so many strands of color—each struggling for survival in the overall impression. No more isolated melodies, the whole thing is a symphony, which itself is life, living and changing, like the "forest voices" of Wagner's theories each struggling for existence in the great voice of the forest, just as the Unconscious, the law

of the world, is a great melodic voice resulting from the symphony of the consciousness of races and individuals. Such is the principle of the Impressionist school of plein air. And the eye of the master will be the one which will discern and render the keenest gradation and decomposition, and that on a simple flat canvas. This principle has been applied in France, not systematically but by men of genius, in poetry and in the novel.

—*Jules Laforgue, 1883*[1]

here has not been a great deal of compelling interpretive writing on Monet's series practice, largely attributable to the immediate dismemberment of the series as series shortly after the works were first shown. By using the term "series" with regard to Monet, the assumption today is that the *Grainstacks, Poplars, Cathedrals* of the early 1890s are what are being primarily discussed, as these were the first ensembles treating a single motif that Monet used to organize and/or control successive one-person exhibitions. But the "series" agenda is much more complex historically; some form of "multiple" or variant practice had been in force in the artist's work almost from the beginning. It is that characteristic of Monet's work that makes the "series" appear ultimately as the

1. Cited in T. J. Clark, *The Painting of Modern Life: Paris in the Art of Manet and His Followers* (New York, 1985), 16.

accumulation and formalizing of pictorial operations that had already developed considerable life and seasoning in practice, particularly after 1876.

Reviewing the scholarship of each decade of the past four, it becomes rather obvious that in each there has been a distinct manner of "period" attention directed to the "series." There is not much in the way of developing interpretation. Rereading the bibliography, one is struck by how much late 1950s writing reflects either cubist or abstract expressionist perspectives,[2] how much late 1960s writing reacts to copies and mechanical reproduction of images,[3] how much late 1970s writing involves itself in questions of subject matter,[4] and finally how much 1980s writing treats social history[5] and such Lacanian notions as knowledge making "knowing" impossible, or at least highly problematic.[6] The bibliography of the "series" therefore tracks

2. Douglas Cooper and John Richardson, *Claude Monet, Edinburgh Festival and Tate Gallery* (London, 1957); Clement Greenberg, "The Later Monet (1956)," in his *Art and Culture* (1961; Boston, 1965), 37–45; William C. Seitz, *Claude Monet—Seasons and Moments* (New York, 1960); and George Heard Hamilton, *Claude Monet's Paintings of Rouen Cathedral* (London, 1960).

3. John Coplans, *Serial Imagery* (Pasadena and New York, 1968); John Elderfield, "Monet's Series," *Art International* 18 (November 1974): 28–46; Grace Seiberling, "The Evolution of an Impressionist, in her *Paintings by Monet* (Chicago, 1975), 19–40; and Steven Z. Levine, "Monet, Lumière and Cinematic Time," *Journal of Aesthetics and Art Criticism* 36, no. 4 (Summer 1978): 441–47.

4. Michel Hoog, "La cathédral de Reims de Claude Monet où le tableau impossible," *Revue du Louvre et des Musées de France* 31, no. 1 (1981): 22–24; Robert Suckale, *Claude Monet, Die Kathedralen von Rouen* (Munich and Zurich, 1981); Robert Shattuck, "Approaching the Abyss: Monet's Era," *Artforum* 20, no. 7 (March 1982): 35–42; and Emile Mauer, "Letzte Konsequenzen des Impressionismus," *Aufsätze zur Geschichte der Malerei* (1975; Stuttgart, 1982). See especially Robert Herbert, "The Decorative and the Natural in Monet's Cathedrals," in *Aspects of Monet: A Symposium on the Artist's Life and Times,* ed. John Rewald and Frances Weitzenhoffer (New York, 1984), 162–75.

5. Horst Keller, *Claude Monet* (Munich, 1985).

6. Steven Z. Levine, "Monet's Series: Repetition, Obsession," *October* 37 (Summer 1986): 65–75.

fairly accurately the most up-to-date critical and historical discourse of the recent past. But has the bibliography become in any sense more than a convenient resting point (or rather a series of resting points) for the practice of discourse as discourse? Judging from Paul Tucker's recent *Monet in the '90s* (New Haven, 1989), the answer would have to be no. While working as a fairly orthodox social historian, Tucker finds himself in a virtual square-one position, from which he has largely to assemble his documentary parts from scratch.

Without intending to criticize Tucker's ambitious efforts overmuch, it does seem that the documents of late nineteenth-century social history fail to yield many significant materials for interpreting or explaining Monet's "series." In order to make them yield *something,* Tucker has had to exercise an exceptionally heavy authorial hand, something that politically unaligned social historians are not supposed to do. Tucker posits a truly amazing number of cultural conflicts—aesthetic ones, marketing ones, and finally national identity ones—in order to drive his use of the considerable body of documentation he assembled for himself.

As he approaches "series" work, Monet is seen as something like a professional football coach preparing himself for the high-cultural "big game." With the big games won, Monet moves relentlessly toward the Super Bowl of French cultural supremacy, with himself posed as the star player, the one with all the moves. Having begun with the agenda of "defeating" Seurat in the late 1880s and early 1890s (*Monet in the '90s,* 15–37), Tucker sees Monet moving largely unchallenged to a point of reputational parity with the great Corot (219–37). The identity that Corot had forged between landscape painting and "great national art" Monet reforges, thereby establishing himself as the undisputed new champion of French painting and, by extension, all of French culture (219–37).

Tucker sees Monet's enterprise as marking itself out between

France's two most significant international embarrassments, the Franco-Prussian War and the Dreyfus affair. Monet becomes for Tucker a kind of Atlas, supporting, by the practice of ambitious modern landscape painting, the enduring myth of France as a nation, and a people whose greatness, virtue, nobility, and fecundity are all embodied in the "land" that is France. That embodiment is permanent and never subject to "defeat" (67, 185). All of Monet's art-political maneuverings after 1880, his aggressive marketing behavior, even his aesthetic decisions seem to Tucker to be substrategies in an encompassing project directed from the start toward the goal line of sole guardianship over the incontestable historical and contemporary greatness of France.

In the process of telling his story of Monet—which is what Tucker seems primarily interested in doing—there is extensive lip service paid to what was going on in Monet's paintings through it all. Each of the "series" is discussed, if by discussion one means accounted for first by sociohistorical and then rather offhanded stylistic and iconographical classification. Ultimately there is not much really about the paintings, even though considerable contemporary critical comment is introduced and there is much (largely pro forma) visual analysis.

But the ambitiousness of Tucker's study cannot and should not be underrated, even though I would argue that if viewed as an interpretation, it must be judged an interpretation of Monet, rather than of Monet's work. As the former it is not uninteresting, and there are more than a few issues of social history proposed that, if not uncontroversial, are at least interesting to consider. Yet in the final analysis Tucker leaves the paintings of the various series aesthetically hanging in midair rather than securely positioned on the walls that Monet intended for them.

The suggestion of "intended walls" is not made here for simple rhetorical effect. No painter before Monet had ever managed to get into a position to "intend" so many walls and to do so over

so many years (nearly forty). Anticipating along with his old dealer, Durand-Ruel, and his new (and second one), Petit, that conditions in the art market would likely change considerably after the major French economic recession of the early 1880s, Monet became a willing, even enthusiastic, devotee of the *very* select group or solo exhibition in well-appointed and prestigious private gallery spaces. Here, rather than at the official Salons, the independent ("impressionist") group exhibitions or the new Salon des Indépendents, Monet found what would be his ultimate exhibition venue and his most successful one. This meant, of course, abandoning his fellow artists of the 1870s, associating with them only rarely in exhibitions and generally going it alone.

Scholars, Tucker among them, see Monet's strategy as largely commercial, and it certainly was, at least in part, but the point can be made that it was aesthetic as well. In the solo or near solo exhibition Monet could sense the natural habitat for his own work: a habitat where what was his referenced itself exclusively, rather than a loosely coherent "movement" like impressionism. During the final impressionist exhibitions in which Monet had participated, he had already begun to present "suites" of work, the paintings of 1877 of the *Gare St.-Lazare* being the best known but hardly the only such. But any form of controlled grouping in the context of the impressionist exhibitions was, whether granted or not, up to the judgment of the year's exhibition organizers. Monet could not absolutely determine how his works were shown, any more than Degas could, or Pissarro. The situation had problems (for Monet at least) that were analogous to old-fashioned Salon ones. This is to say, one might have work shown, only to have its effect completely compromised by insensitive hanging. Certainly the hanging risks faced in an impressionist group exhibition were not so substantial as those faced at a Salon, but they were of the same type, and for Monet who

was increasingly focusing his work of the early 1880s on "suites" or ensembles, the risks were very real.

If one assumes, as I think one can, that Monet had tended after 1876 to work on and to finish closely related (motifically) groups of works simultaneously and with much comparative reference in his studio, then the problem of having that achieved "finish" disrupted by "breaking up" the groupings becomes obviously substantial. There is not enough photographic or reliable written documentation of the hanging of the late 1870s impressionist exhibitions to suggest exactly how great the problem was for Monet, how or whether it was handled in any useful fashion. However, it appears possible, even likely, that groups such as the *Gare St.-Lazare* paintings were randomly broken up in the hanging.[7]

It is impossible to approach Monet's mature "series" practice without considering the above, and considering it seriously not just as marketing, but as aesthetics as well. His painting, because of how he was going about it around 1880, was not well served being seen in pieces—even though individual pieces might be and often were stunning images. The solo or partly solo exhibition was a virtual necessity for Monet's work to appear in public as it did in his studio. But the interesting question that emerges out of this is, For how long did the solo exhibition contain "suites" or ensemble work, and at what point did the solo exhibition become as a routine of display itself the encouragement of the ever more closely connected "series" mode of work that Monet undertakes in the late 1880s?

Like all truly interesting questions of an art-historical sort, this one has no definitive answer. But what can be said is that Monet, through whatever process, became the first virtuoso player of the solo exhibition. This was an achievement recog-

7. Charles S. Moffett, *The New Painting—Impressionism: 1874–1886* (San Francisco, 1986), 189–202.

nized early on by such severe critics as Degas and Pissarro.[8] Whatever encouraged the amalgam of the solo and the "series," it certainly worked, and it worked well enough to position Monet (in terms of accomplishment) at the very forefront of modern French art by 1895.

The developing, first of the solo exhibition and then the formalization of the "series" in Monet's work, encourages some more or less directed background speculation. As already suggested, 1876–1877 and the *Gare St.-Lazare* paintings seem to have provided some sort of aesthetic signal (or at least protosignal) indicating that effectively new strategies (or at least revised ones) were at work in Monet's practice. He was not jumping from motif to motif *en plein-air* as he had been in the earlier 1870s. Instead, he was seeming to concentrate, not, perhaps, like Manet, on the "masterpiece" of the year, but at least on a clearly and closely interactive body of major work.

At just about the same time as Zola was to voice his troubled feelings regarding the "impressionist lack of system,"[9] Monet seems to have intuited something very similar, and to have begun to act on that intuition. One can responsibly date the much-discussed "crisis" of impressionism to Monet's at first only marginally disciplined inclination in the direction of producing a demonstrably conclusive year's work.[10] At Vétheuil he had continued after 1878 to toy with something like distributed conclusiveness in loose groupings of paintings, and this practice would develop with increasing focus on key motif types on the Normandy coast well into 1885.

8. Ibid., 113. See negative judgment later reversed, 266.

9. Emile Zola, *L'Oeuvre* [1886], trans. Thomas Walton (Ann Arbor, Mich., 1968); and *Mes Haines* [1883] (Paris, 1928), esp. 259–307. For ambiguous 1876 attitude, see Zola, "Deux expositions d'art du mois de mai," *Messenger d'Europe* [St. Petersburg] (June 1876).

10. Joel Isaacson, *The Crisis of Impressionism: 1878–1882* (Ann Arbor, Mich., 1980), 1–47.

When Zola's *L'Oeuvre* appeared, it caught Monet (one suspects) off-guard. The result was Monet's almost uniquely troubled letter to Zola, the first part of which has already been quoted at the end of Chapter 2. After "finding" memories on every page, Monet continues: "I have been struggling for a long time and I am afraid that just as we are about to meet success, our enemies may make use of your book to overwhelm us."[11] The use of first-person singular at the beginning of the sentence, and the shift to first-person plural in the remainder, is puzzling and interesting, since it clearly positions Monet's sense of his own working operations as an individual, but his market (and/ or aesthetic-penetration problem) as still joined to the larger impressionist group. Monet clearly felt that he was working through something at the very point Zola held out the flag of failure. And it is at least arguable that Zola's sense of failure, and Monet's "struggling," represent in fact one and the same condition. Yet to call it crisis is *too* generic.

Monet's struggles, Renoir's, and Pissarro's, were all their own and all distinct. But only Monet's finally led to a circumvention of the traditional notion of the conclusive masterpiece—a circumvention managed by what will be discussed here as the distributed masterpiece—the "series." In 1886 Zola had perhaps caught Monet just at the point when the painter was doing what might, had it been known, have prevented Zola from saying what he did (and in fact what he had been saying in print for several years).

The relationship between Monet and Zola is not well documented prior to the Dreyfus affair, when Monet joined with Zola's famous protest.[12] But, as his letter responding to the reading of *L'Oeuvre* indicates with its "moreover you are aware of my fanatical admiration for your talent," Monet was and

11. Cited in Sven Loevgren, *The Genesis of Modernism: Seurat, Gauguin, Van Gogh, and French Symbolism in the 1880s*, rev. ed. (Bloomington, Ind., 1971), 41.
12. Tucker, *Monet in the '90s*, 239–42.

presumably had been an enthusiast for Zola for a considerable time, and personally Zola knew it.[13] By 1885–1886 Monet had not, however, convinced Zola in his work that the "impressionist masterpiece" was close at hand. Not even Manet had managed that, unless one reads Zola's marginalizing of the late Manet as tacit recognition that he had, albeit in less than acceptable (by Zola's standard) terms.

With the publication of *L'Oeuvre* Zola exposed (perhaps unintentionally, perhaps not) all of his painter friends with their aesthetic pants down, or at least sagging. Monet was just getting his ensemble practice together, Pissarro was testing "progressive" neo-impressionist waters, Renoir was vacillating between Wagner and Italian Renaissance fresco painting, and Degas was experimenting, as he frequently did, with various print media. Cézanne had no truly established stature among any but the most closed circle of the most advanced painters— Gauguin, Van Gogh, Monet, and Renoir. Manet was dead, and the Seurat circle represented an art/science merger that Zola, like so many realists and/or impressionists, found absolutely abhorrent—not just threatening, but truly inartistic.

The Monet that felt bludgeoned by Zola's *L'Oeuvre* was a Monet in the midst of major readjustment of aesthetic self-definition: not so much in crisis as in a situation of change, the outcome of which was not yet clear. However, what I would suggest really stung in Zola's novel was the insistence on aesthetic demonstration via the masterpiece. In Zola's terms, a masterpiece had to be a masterpiece in the truly old-fashioned sense: the single work where all experimentation came conclusively together. Yet, Zola himself, it could be argued, had avoided this kind of masterpiece accounting by embarking upon (or at least projecting in the late 1860s) not a single literary masterpiece goal but a "series" one. Yes, each novel of the

13. Loevgren, *Genesis of Modernism.*

Rougon-Macquart series was to be self-sufficient, but the "series" was, by implication from the start, the masterpiece, systematically worked toward and at some point conclusively achieved.

Did Monet develop (consciously or unconsciously) the "series" notion from Zola? And is it that which made him so especially sensitive to Zola's texting of realist pictorial failure? And is it the echo of this sting that encouraged Monet to organize the subscription to purchase (in self-defense?) Manet's *Olympia* (the most widely recognized progenitor of "the new painting") for the state in 1889? These are all intriguing questions that can never be answered satisfactorily, largely, one suspects, because the major operative, namely, Monet, could probably never have answered them himself. The point to be made here is that whatever the case, the masterpiece/"series" issue was very definitely "up" in the early 1880s. Zola had anticipated it and worked out his own writer's strategy; Monet had sensed it, but only gradually came to understand, pictorially speaking, what it meant and how to proceed.

As William C. Seitz suggested in 1960, "If a sufficient number of works from the eighties could be brought together, the degree to which the series method is potential in them would be evident" (*Seasons and Moments,* 19). Unfortunately, the exhibition "Monet in the 1880s" has yet to be mounted, so we are in no better position today than Seitz was to examine in the presence of the paintings themselves the imminent gestures in the direction of "series" work in Monet. We've seen the "series" of the 1890s, and we've seen the London pictures[14] in separate exhibitions at different locales, but we've not been gifted with the progenitor pictures in sufficient numbers to make really

14. Grace Seiberling, *Monet in London* (Atlanta, Ga., 1988).

certain conclusions regarding Monet's intuitions, his conscious plans, his changes of mind.

What we do know is that by the mid-1880s Monet had begun the practice of going into the out-of-doors with not one but several canvases in tow. Returning to the same motif day after day, the canvases would be worked on in some sort of sequence, presumably reactive to particular conditions of light. Seitz quoted for the first time an 1886 report by the novelist, Guy de Maupassant, on Monet's working method. It is likely an at least partly reliable, if romanticized, description of what de Maupassant actually witnessed:

> Last year . . . I often followed Claude Monet in his search of impressions. He was no longer a painter, in truth, but a hunter. He proceeded, followed by children who carried his canvases, five or six canvases representing the same subject at different times of day and with different effects.
>
> He took them up and put them aside in turn, following the changes in the sky. And the painter, before his subject, lay in wait for the sun and the shadows, capturing in a few brushstrokes the ray that fell or the cloud that passed. . . .
>
> I have seen him thus seize a glittering shower of light on the white cliff and fix it in a flood of yellow tones that strangely rendered the surprising and fugitive effect of the unseizable and dazzling brilliance. On another occasion he took a downpour beating on the sea in his hands and dashed it on the canvas—and indeed it was the rain he had thus painted. . . . (*Claude Monet*, 20)

It is interesting that de Maupassant published his description in the magazine *Gil Blas* just a few months after that same magazine had completed its serial publication of Zola's *L'Oeuvre*. Already

it seems there was something sensed as brewing between Zola's novel of failure and Monet's conveying of painting in a new, yet to be precisely specified, realist direction. As is well known, Monet would use a program of travel to rugged and geologically peculiar locales between 1885 and 1888, first to Belle-Isle-sur-Mer and then to the Massif Central and the valley of the Creuse River, to work out with fresh motifs in front of his eyes the practice of "multiples" that de Maupassant had seen as early as 1885 as a well-established matter. What is most important is that proto- (or pre-)series practice had already by 1885 begun to involve not just ensembles of motifs from a particular locale, but "the same subject" in more than one canvas. De Maupassant was writing about his experience of Monet at Etretat, so from that point at least it is possible, even necessary, to see Monet involving himself in some quasi-systematic way with a significant forward mutation of impressionist practice.

Whether anticipating, paralleling, or reacting to Zola, Monet had, by the time *L'Oeuvre* appeared, begun to remodel his practice of painting—not technically but programmatically. Now he would make exhaustive pictorial explorations rather than somewhat random, panoramic ones, as were characteristic of the *Gare St.-Lazare* group and the several years of work from the village of Vétheuil. Would Zola have either recognized the import of Monet's new strategy around 1885, and, if he had, would he have respected it? Probably not, because what was still lacking was the "masterpiece"—the empirically distilled and consolidated aesthetic achievement.

Zola's approval or understanding aside, Monet had begun more or less regularly after 1880 to plot campaigns of work at single locations, using the similarity, rather than the variety of motifs chosen, to direct him from painting to painting. By 1885 he had developed the practice of working on several canvases in rapid succession, first out-of-doors and then at a certain point moving indoors. Obviously, he needed to begin his pictures in

the presence of particular natural moments of light, moments to which his eye had become greedily hypersensitive—so much so that apparently similar moments of light could be made dissimilar as the feeling induced carried over into the working life of a group of paintings. The result of Monet's new method of work was to provide him, before moving into the studio, with a considerable number of color drafts for motifically similar images. These drafts each possessed a certain chromatic peculiarity that would be developed, but never abandoned, as the paintings were brought to a state of finish (in Monet's terms) where picture to picture continuities emerge via the relative consistency of surface structure Monet devises as the technical dominant in each related group (protoseries or series) of works.

From Etretat to the *Rouen Cathedral* series there is an identifiable kind of finish unique to each campaign of work and cross-referenceable only loosely to other groups. A certain kind of dry stipple is dominant in the Etretat pictures, a raggedness of surface strokes and edges in those from Belle-Isle, an alternation of statically deposited color spots and "flowing" ones in those from the Creuse valley, virtually strawlike webs in the *Grainstacks,* cursive flotations of drawing with paint in the *Poplars,* and dense, dry, almost brushstroke-denying encrustations in the surface of the *Rouen Cathedral* pictures. One could go on at some length to characterize the autograph of surface characteristic of Monet's series work after 1895, but what one would see is simply a continuity of a type of "finishing" practice already clearly in place.

It is ultimately the surface consistency apparent in groups of work done, particularly after 1885, that gives Monet the opportunity to shift the focus of his originality into differentials of coloration. Sometimes these differentials are broad, at other times very slight, but whether broad or slight the idiosyncrasy of any given picture within a group is never sufficiently intense chromatically to erode the dominating structure of that group's

prevailing surface. For chromatic intensity Monet substitutes chromatic variety both within individual pictures and across whole groups. The variety unfolds gradually, and by the standards of Monet's earlier work, rather softly (or quietly). Strong contrasts of hue or value disappear increasingly in his work after 1885; by the time of the *Rouen Cathedral* pictures, each member of the series is made to feature only one prominent opposition of complementary colors, and this featuring is always dispersed by virtually infinite subdivisions and variations of value.

What Monet seems to have done in the completion stages of his work on closely related groups of paintings, particularly around 1890, was to work toward a picture-to-picture balance of established surface character for each group, and a manageable chromatic variation within that surface-defined structure of finish. Paintings became exhibitable when, and only when, they yielded as an ensemble in Monet's studio a continuous visual sounding of comparatively consonant surface and chromatic chords. What they showed in the studio could be easily reshown in the solo gallery exhibition, which is the context (as mentioned earlier) in which they were routinely seen. More than any artist before and perhaps even since, Monet managed to anticipate, and as a result dissipate, the risks of moving his work from studio to exhibition. His practice left room for as few surprises as possible. He managed something like continuous equivalency from one painting to another within his groups; in fact, he built that equivalency into his whole painting process with the result that a sense of absolutely consistent "rightness" prevailed when the paintings were first shown. No paintings have likely ever appeared so right when seen together for the first time, and most sympathetic contemporary viewers of Monet's grouped works (and eventually his series) recognized that this rightness was of a highly special *and* highly refined sort.

The groupings were a masterpiece and each group held onto and amplified its gallery walls in very particular ways, and very

original ways as well. Hovering, quaking, flowing, feeling at one instance poised, at another dissolving, paintings from Etretat to Rouen elaborate upon wall-based (decorative in the traditional academic sense) imaging as richly as has ever been managed by any artist. As has frequently been remarked, all gestures toward pictorial space and/or fixed volume are abandoned as Monet moves toward and into series practice.[15] This seems in retrospect to have been a virtual necessity given the particular form of *his* masterpiece enterprise. What Monet got in exchange for what he gave up was the ability—at least at the time the paintings first appeared together—to generate a sensation of movement through time.

On the few occasions this author has had to see comparatively large regroupings of Monet's post-1883 work, the prevailing sensation of movement has been of a kind of sequential stop-action photographic sort, rather than a cinemagraphic (persistence of vision) sort. It is highly important that this sensation prevails, and Monet must have been aware of the importance. The perceptual fiction of stop-action sensation is ultimately what would support the notion of individually masterly and original paintings within a collective masterpiece. The fiction would, in other words, make the groups or series salable in fragments. Each painting could be read as a fictively discrete moment, complete in itself, while at the same time standing when the occasion arose as something more like an aspect, or perhaps better, an inflection within a much larger (and longer) experience—and a more literally durable or durational one.

One must try to imagine the experience of seeing twenty-plus paintings from Monet's series of the early 1890s in the same space. No contemporary commentaries seem able to account for the sensation very coherently, and it is highly typical of contem-

15. See Greenberg, *Art and Culture*.

porary discourse (of the 1890s) to slip almost instantly into the elaboration of one or another form of musical analogy.[16] As has been persistently noted throughout this book, the discursive conditions for the musical analogy to be called into play at this historical point, and in particular around the kind of work Monet was doing, were very much in place. Whether looking at one critic or many, the reliance on the musical analogy to describe the experience of the series has a feeling of inevitability about it. How else in the early 1890s *could* Monet's efforts have been described except musically? Virtually everything else in advanced French culture was receiving similar discursive treatment, and Monet's work arguably merited "musical" discussion more demonstrably than any other. Camille Mauclair probably elaborated the musical analogy vis-à-vis Monet more extensively than any other writer, and over a longer period. His discussions of something like the "symphonization of color" remain period-based, yet highly informed by his own writing on contemporary music, his cultural first love.[17]

What the series exhibitions did to unleash the musical analogy in contemporary criticism as comprehensively as they did was, I would suggest, to inspire the analogy with a new and different form of experience. Durationality, sequence, color moving both on and forward of the gallery walls, colors from one point conversing within the spectator's eyes with color or colors from another point—the whole complex sensation transpiring in and through the literal space of real rooms becoming increasingly abstract and detached from precise image sources—this was truly musical. Color *was* activating—besides walls—sensations, and very complex ones at that, of some kind of mysterious

16. Kermit S. Champa, *The Rise of Landscape Painting in France: Corot to Monet* (Manchester, N.H., and New York, 1991), 58–59.

17. *L'Impressionisme—son histoire, son ésthetique, ses maîtres* (Paris, 1904), 43.

inner penetration of space and time.[18] Like music it was energizing ("decorating" in period terms) a whole ambience and doing so with sequences of statements, developments, counter-statements and counter-developments, occasionally even with cadences of a sort. And even more to the point, all that was experienceable was so only as perception, with motific repetition making "reading" subjects, if not impossible, at least highly uninteresting. Zola's much-feared slippage of realist painting into musical abstractness had occurred! Painting would never be the same again.

It has been tempting for many scholars to assume that Monet, in the process of developing his full-blown "series" practice in the early 1890s, was reacting in one way or another to the new epistemology of Henri Bergson, which was gaining recognition at about the same time.[19] Bergson's notion of the unfixed nature of what perception could only interrupt temporarily certainly has some strong resonance with Monet's practice, as do the post-Bergsonian elaborations of the so-called fourth dimension of space-time. While it is not inconceivable that Monet and/or some of his contemporary critical advocates had some rough sense of what was in the air in formal philosophy, it seems doubtful that anything like knowledge in depth of Bergson (or any of his contemporaries) was even remotely in place in France (or anywhere else for that matter) much before the first decade of the twentieth century. This being the case, it seems safe to assume that Monet's series practice emerged from well-established earlier models, both aesthetic and philosophical. Obviously, the present author

18. Georges Lecomte, "Des tendances de la peinture moderne" [1892 XX Conference, Brussels] *L'Art moderne* 12, nos. 7, 8, 9 (February 1892), where the author sees music as *the* decorative art form.

19. This discussion began in George Heard Hamilton, "Cézanne, Bergson, and the Image of Time," *College Art Journal* 16 (Fall 1956): 2–12. It remains a semilive issue in Tucker, *Monet in the '90s,* 93.

gives much more weight to the ongoing discourse linking the operations of painting and music, and the potential resident in both to generate elaborate structures of pure feeling through the manipulation of media-specific techniques, possibly laced with some form or other of synaesthetic resonance, or pretense.

Ultimately what seems most abrupt, radical, and in some way new in Monet's group and series work is the problematic status occupied by the individual painting, once a grouped ensemble is dispersed. Speaking as a critic, I have to admit that no single member of any Monet group or series, seen alone, manages to impress its aesthetic weight as powerfully as is the case when more than one appears grouped. In Paris or Chicago where it is possible to see four or more *Cathedrals* or *Grainstacks* hung together on a routine basis, the effect is, somewhat surprisingly, for each individual painting to look more "individual" than part of a group. This is not to suggest that a group collapses under the presence of numbers; rather, it is to say that grouping *individualizes,* or at least seems to, while at the same time *regrouping* a composite, conversive effect. And, I must confess that I have always found the opposite to be the case with Cézanne's contemporary work, where individual paintings are most powerful seen in isolation, in much the same way *most* traditional painting functions. In every Cézanne there is some sort of internally calibrated closure that operates absolutely. In every later Monet the closure is only relative, and subject to being revised in company with other Monets.

I use the generic term "other" Monets here to introduce as an additional point, a point of a personally experienced (not once but many times) sort. I find that Monet's paintings from whatever period, but particularly after the mid-1870s, *love* to be grouped, and appear at their strongest when grouped, even if the grouping involves paintings from many campaigns (groups or series of work). I sincerely doubt whether Monet's achievement as a painter would ever have impressed itself on me as

strongly as it did, were it not that for nearly a decade I was able to visit the Boston Museum of Fine Arts and stand literally transfixed for hours on end, week after week, in the Fenway hemicycle that held arguably the greatest sum of post-1878 Monets anywhere in the world.

The installation of Boston's Monets in and around the Fenway hemicycle was never absolutely fixed. Pictures were moved around now and then, but there were always some *Cathedrals* and *Grainstacks,* some Creuse paintings, some Normandy coast pictures from the early 1880s, a Japanese footbridge, and one or more early *Water Lillies* in close proximity, with other random paintings, mostly early Giverny works, mixed in. Whatever the mix, it always seemed to work marvelously and one got a different emotional jolt from one or another picture on every visit. No subsequent installation at Boston has ever managed to make that collection's holdings seem so strong, either in terms of individual paintings, or as a composite treasure. Other museums, the Metropolitan in New York, and the Musée d'Orsay in Paris, have attempted other versions of consolidated or quasi-consolidated installation of their considerable Monet collections, but neither has managed, any better than Boston, to reproduce the "Fenway effect."

To describe the "Fenway effect," I am inclined to stress the space in which the installation of Boston's Monets occurred. By most museum standards the Fenway hemicycle is (without its Monets) a "problem" space—the rotunda around the top of a large formal staircase—fit only, it seems (nowadays at least), for rows of second-rate portraits or other main-gallery leftovers. But the space was perfect for Monet. The walls, although curved (and *because* they are curved) are continuous, or at least relatively so. Paintings could be viewed in sequence up close, and from a distance—across the staircase—as ensembles. And the air across that staircase was positively electrified by Monet's color. The paintings, for me at least, sang to each other from

every direction. In retrospect, I remember that "singing" as much as I remember any particular instance of seeing. The Fenway installation would be hard to duplicate elsewhere.

Both the Boston paintings *and* the oddities of the Boston Museum's architecture are to a significant degree unique. But I would suggest that the "Fenway effect" was a standard by which all other Monet installations ought to be judged, since it contained as completely as any post–first-gallery solo showing possibly could the reciprocating dependence and independence of Monet's work seen at its absolute of sheer aesthetic power. By comparison, Boston's installation of the exhibition *Monet in the '90s* of 1989 was congested, pedantic, and, what is worse, altogether "silent." For a Monet installation anywhere, silent means stillborn.

Coda

It is highly unlikely that Monet knew much, if anything, about Vincent Van Gogh's work. And, given the persistent striving for refinement of effects in his late 1880s work, it seems equally unlikely that Monet would have been in any way impressed by the graphic and coloristic boldness of Van Gogh's practice. The fact that the latter's practice owed a great deal after 1886 to Monet's own early 1880s work would hardly have helped the situation. Van Gogh would and frequently did recognize Monet's achievement, but there would not have been any truly compelling reasons for Monet to reciprocate the respect. Viewed comparatively, there could not be greater differences in the employment of so-called impressionist practice than exist between the paintings of the two artists. But, these differences aside, there are some underlying similarities that deserve to be noted. Perhaps the similarities are pure coinci-

dence, but more likely they suggest something about certain natural, even necessary, inclinations in later impressionist pictorial practice generally.

The ensemble and the close-knit group of images are broadly characteristic of both Van Gogh's and Monet's aesthetic enterprise after 1888 especially. In his *Sunflower* paintings, Van Gogh produced an extended group of motifically similar, at times nearly identical, images as large as any Monet would manage until the mid-1890s.[20] Moreover, like Monet, he considered various ways (at various times) of hanging at least some of the *Sunflowers* together. The best known of these ways were the "decoration" of Gauguin's room before his arrival in Arles in 1888 and the projected display of one or another *La Berceuse* flanked by *Sunflowers* on either side (*Letters,* III, no. 574, 129). While it would be forcing a point to suggest that the *Sunflowers* were in any sense a series or semiseries in Monet's terms, the fact that Van Gogh produced so many of them over so short a period of time suggests that in a way not unlike Monet, Van Gogh worked a single motif until it exhausted itself. For as long as the passion to paint *Sunflowers* persisted, and for as long as the results seemed strong, Van Gogh painted them. Very much the same is, as we have seen, true of the *Berceuse* project, where "original" copies (new performances) persist for as long as the artist felt he had, so to speak, another one to go.[21] Also, the conception of *La Berceuse,* from the beginning it seems, involved the making of site-specific (although the site was a imaginary one) expressive decoration.

Multiplication of images, with each successive one developing in relation to others after the first was envisioned, and the cou-

20. Vincent Van Gogh, *The Complete Letters of Vincent Van Gogh,* 3 vols., Introduction by V. W. Van Gogh and Preface by J. Van Gogh-Bonger (Greenwich, Conn., 1958), III, no. 526, 18–19; esp. no. 528, 21.

21. Van Gogh is not at all committed in his discussion of *Sunflowers* paintings as multiples or copies. *Letters,* III, no. 575, 132.

pling of this process with some loosely defined decorative role: the situation is more alike than different in Monet's and Van Gogh's practice, although neither would likely have recognized it as such. An incipient "installation" mentality seems to have developed, granted for very different reasons, in both artists at just about the same time, although the mentality has a considerable prehistory in Monet's work that Van Gogh seems just to intuit and accept in passing. The fact that Monet was envisioning grand solo gallery exhibitions, and Van Gogh, the more humble notion of making healthy and pleasant his own and Gauguin's lodgings, actually makes very little difference. Both artists were involved in using their paintings, grouped in *their* way, to control a particular space in a premeditated and at least partly predetermined fashion. The greatest tragedy of Van Gogh's abbreviated career exists in the abrupt closure of living time available to him to work out fully his notions about (or instincts regarding) painting determined spaces as installations. Monet was, of course, more fortunate by more than thirty years!

In that thirty years, besides producing the triumphant succession of solo "series" exhibitions, and with the ever larger *Water Lily* paintings moving toward something like the great solo space of the Orangerie commission, Monet did something else that both flows from and in certain ways perhaps even guides his painting practice. The elaborate water garden and its carefully planned surroundings at Giverny occupy Monet nearly as constantly as does the production of paintings from the mid-1880s until the end of his life. Like "series" painting, Monet's crafting of his own "natural" setting involves decoratively coordinated total control of a limited space. With sometimes simple, sometimes exotic plantings and combinations of land, water, and a Japanese-style bridge, Monet manages a "natural" series that changes from year to year and season to season, while always remaining in essence the same place.

Monet had always been a gardener, just as he had always been

a painter. Manet's most "familiar" portrait of Monet from the mid-1870s at Argenteuil (New York, Metropolitan Museum of Art) pictures Monet in the left middleground watering his flowers and otherwise tending them, while his wife and son sit informally on a patch of grass in the center of the painting. In other Argenteuil portraits, Manet painted Monet painting in his studio boat. He saw the two sides of his younger colleague very clearly, and quite likely had some intuitions about Monet that can only be at this point subjects of conjecture. At the risk of appearing intellectually trendy, I would suggest that in some manner Manet was very sensitive to the "female" side of Monet—the tending, decorating, nurturing side. Manet seems to have known that Monet had abandoned pursuit of the conventional (male) masterpiece fairly conclusively by the time he became the subject of Manet's several Argenteuil portraits. Manet had, of course, not given up the pursuit, nor would he ever.

In a now rather infamous essay written in the early 1890s by the Irish critic (and comparatively close acquaintance of both Manet and Monet), George Moore attempted to characterize in broad terms the artistry particular to men and to women.[22] He felt that artistry was gender-specific, his reasoning being that, since no painting by a woman had ever been an indispensable historical part of the medium's past (he says this even while genuinely respecting Berthe Morisot's work) perhaps painting was not a productive female artistic pursuit. Conversely, and rather predictably, he found the artistic instincts of women most present in their ability (an ability apparently denied to men) to decorate, to arrange, to ornament—particularly domestic spaces. Assuming Moore's perspective, period-specific as it is, one would be inclined to label Monet's mature artistic enterprise—both his paint-

22. "Sex in Art," in his *Modern Painting* (London, 1893), 220–31. See also André Fontainas and Louis Vauxelles, *Histoire générale de l'art français de la Révolution à nos jours*, 3 vols. (Paris, 1922), final chapter, "Les femmes peintres d'aujourd'hui."

ing and his gardening—as being as much, if not more, female than male, or at least partaking considerably of the former in its behavioral characteristics.

Without intending to belabor the point, the notion of the "mistresspiece" advanced in Chapter 2, might, along with Moore's characterization of gender-specific artistry, be profitably brought forward to label Monet *a crafter of "female" spaces using pictorial multiples*. This label, whether useful or just alien to the reader, does, it seems to me, penetrate at least slightly the radically tensional character of Monet's later painting enterprise and expose a significant aspect of its modernness. I doubt that one needs to reintroduce the notion of pictorial multiorgasmicity to make the label any more secure.

Is there anything else one might bring forward to secure the label? Perhaps the music model? An old chestnut of Wagnerist ideology—the ideology that so substantially informs most early writing on Monet's "series" work—counts music as female and its creator as male. If the "series" seemed so self-evidently musical when they first appeared, does that mean that Monet was identified by affective analogy with creating music, or *being* music in the role of a painter? The critical record is not clear on this point, and neither is the present author. The confusion, however, is endlessly provocative, or at least ought to be.

Select Bibliography

Arikawa, Haruro. "'La Berceuse': An Interpretation of Vincent Van Gogh's Portraits." *Annual Bulletin of the National Museums of Western Art* [Tokyo] 15 (1981): 31–75.

Aubéry, Pierre. "Zola peintre et la littérature." In *Emile Zola and the Arts: Centennial of the Publication of l'Oeuvre.* Edited by Jean-Max Guieu and Alison Hilton, 1–8. Washington, D.C., 1988.

Baedeker, K. *Paris und seine Umgebungen.* Paris, 1878.

Baguley, David. "*L'Oeuvre* de Zola: Künstlerroman à thèse." In *Emile Zola and the Arts: Centennial of the Publication of L'Oeuvre.* Edited by Jean-Max Guieu and Alison Hilton, 185–98. Washington, D.C., 1988.

Benjamin, Walter. *Illuminations.* Edited and with an Introduction by Hannah Arendt. Translated by Harry Zohn. New York, 1968.

Borel, France. *Le Modèle: où l'artiste séduit.* Geneva, 1990.

Brady, Patrick. *L'Oeuvre d'Emile Zola, roman sur les arts.* Geneva, 1967.

———. "Pour une nouvelle orientation en sémiotique: A propos de *L'Oeuvre* d'Emile Zola." *Rice University Studies* 63 (1977): 43–84.

———. "Rococo versus Enlightenment: A View from Naturalism." *Oeuvres et Critiques: Revue Internationale d'Etude de la Réception Critique d'Etude des Oeuvres Littéraires de Langue* 10, no. 1 (1985): 67–72.

Breisach, Ernst. *Historiography—Ancient, Medieval, and Modern.* Chicago, 1983.

Cachin, Françoise, Charles S. Moffett, and Michel Merlot. *Manet 1832–1883.* New York, 1983.

Carrier, David. "Art History in the Mirror Stage: Interpreting *Un Bar aux Folies-Bergère.*" *History and Theory: Studies in the Philosophy of Art History* 29, no. 3 (1990): 297–319.

———. *Principles of Art History Writing.* University Park, Pa., 1991.

Champa, Kermit S. *The Rise of Landscape Painting in France: Corot to Monet.* Manchester, N.H., and New York, 1991.

———. *Studies in Early Impressionism.* 1985. Reprint. Hacker, New Haven, 1973.

———, ed. *Edouard Manet and the Execution of Maximilian.* Providence, R.I., 1981.

Clark, T. J. *The Painting of Modern Life: Paris in the Art of Manet and His Followers.* New York, 1985.

Cooper, Douglas. *The Courtauld Collection.* London, 1954.

———, and John Richardson. *Claude Monet, Edinburgh Festival and Tate Gallery.* London, 1957.

Coplans, John. *Serial Imagery.* Pasadena and New York, 1968.

Duncan, Phillip A. "The Art of Landscape in Zola's *L'Oeuvre.*" *Symposium: A Quarterly Journal of Modern Foreign Literatures* 39, no. 3 (1985): 167–76.

Duranty, Louis Emile Edmond. *La Nouvelle Peinture.* 1876. Reprinted in *The New Painting—Impressionism: 1874–1886,* by Charles S. Moffett, 477–84 (French); 37–50 (English). San Francisco, 1986.

Duret, Théodore. *Manet and the French Impressionists.* 1878. Translated by J. E. Crawford Fitch. London, 1910.

Elderfield, John. "Monet's Series." *Art International* 18, no. 9 (November 1974): 28–46.

Fontainas, André, and Louis Vauxelles. *Histoire générale de l'art français de la Révolution à nos jours.* 3 vols. Paris, 1922.

Frey, John. *The Aesthetics of the Rougon-Macquart.* Madrid, 1978.

Fried, Michael. *Courbet's Realism.* Chicago, 1990.

———. "Manet's Sources." *Artforum* [Special Issue] 7, no. 7 (March 1969): 28–82.

———. *Realism, Writing, Disfiguration: On Thomas Eakins and Stephen Crane.* Chicago, 1987.

Fry, Roger. *Vision and Design.* 1920. Reprint. New York and Scarborough, Ontario, 1956.

Greenberg, Clement. *Art and Culture.* 1961. Boston, 1965.

Guieu, Jean-Max, and Alison Hilton, eds. *Emile Zola and the Arts: Centennial of the Publication of l'Oeuvre.* Washington, D.C., 1988.

Hamilton, George Heard. "Cézanne, Bergson, and the Image of Time." *College Art Journal* 16 (Fall 1956): 2–12.

———. *Claude Monet's Paintings of Rouen Cathedral.* Charleton Lecture, 1959. London, 1960.

Hanotelle, Micheline. "Léo Gausson et Zola (Réflexions relatives à une lettre du peintre Léo Gausson à Emile Zola et réponse inédite du romancier)." *Les Cahiers Naturalistes* 63 (1989): 193–203.

Hanson, Anne Coffin. *Manet and the Modern Tradition.* New Haven, 1977.

Herbert, Robert. "The Decorative and the Natural in Monet's Cathedrals." In

Aspects of Monet: A Symposium on the Artist's Life and Times. Edited by John Rewald and Frances Weitzenhoffer. New York, 1984.

————. *Impressionism: Art, Leisure, and Parisian Society.* New Haven, 1988.

Herding, Klaus. "Review of T. J. Clark, *The Painting of Modern Life: Paris in the Art of Manet and His Followers.*" *October* 37 (Summer 1986): 113–25.

Hofmann, Werner. "Der Künstler als Kunstwerk." *Deutsche Akademie für Sprache und Dichtung, Jahrbuch* (1982): 50–65.

————. *Nana: Mythos und Wirklichkeit.* Cologne, 1973.

Holly, Michael Ann. *Panofsky and the Foundations of Art History.* Ithaca, N.Y., 1984.

Hoog, Michel. "La Cathédrale de Reims de Claude Monet où le tableau impossible." *Revue du Louvre et des Musées de France* 31, no. 1 (1981): 22–24.

House, John, Dennis Farr, Robert Bruce-Gardner, Gerry Hedley, and Carline Villers. *Impressionist and Post-Impressionist Masterpieces: The Courtauld Collection.* New Haven, 1987.

Isaacson, Joel. *The Crisis of Impressionism: 1878–1882.* Ann Arbor, Mich., 1980.

Jennings, Chantal. *L'Eros et la femme chez Zola: De la chute au paradis retrouvé.* Paris, 1977.

————. "Zola féministe?" *Cahiers Naturalistes* 44 (1972): 172–87.

Jullien, Adolph. *Richard Wagner: Sa vie et ses oeuvres.* Paris, 1886.

Keller, Horst. *Claude Monet.* Munich, 1985.

Knapp, Bettina. "The Creative Impulse—to paint 'Literarily': Emile Zola and the Masterpiece." *Research Studies* [Washington State University] 48, no. 2 (June 1980): 71–82.

Krakowski, Anna. *La condition de la femme dans l'Oeuvre d'Emile Zola.* Paris, 1974.

Kubler, George. *The Shape of Time.* New Haven, 1962.

LaForgue, Jules. *Selected Writings of Jules LaForgue.* Edited and translated by William Jay Smith. New York, 1956.

Lecomte, Georges. "Des tendences de la peinture moderne." Twentieth Conference, Brussels, 1892. *L'Art Moderne* 12, nos. 8–9 (February 1892): n.p.

Leduc-Adine, Jean-Pierre. "Paris et l'ordre spatial dans l'Oeuvre." In *Emile Zola and the Arts: Centennial of the Publication of L'Oeuvre.* Edited by Jean-Max Guieu and Alison Hilton, 165–75. Washington, D.C., 1988.

Lehmann, A. G. *The Symbolist Aesthetic in France: 1885–1895.* Oxford, 1950.

Levine, Steven Z. "Monet, Lumière and Cinematic Time." *Journal of Aesthetics and Art Criticism* 36, no. 4 (Summer 1978): 441–47.

————. "Monet's Series: Repetition, Obsession." *October* 37 (Summer 1986): 65–75.

Loevgren, Sven. *The Genesis of Modernism: Seurat, Gauguin, Van Gogh, and French Symbolism in the 1880s.* Rev. ed. Bloomington, Ind., 1971.

Mauclair, Camille. *The French Impressionists.* London, 1903.

———. *L'Impressionisme—son histoire, son ésthetique, ses maîtres.* Paris, 1904.

Mauer, Emile. "Letzte Konsequenzen des Impressionismus." *Aufsätze zur Geschichte der Malerei.* 1975. Stuttgart, 1982.

Meier-Graefe, Julius. *Modern Art.* 2 vols. Translated by Florence Simmonds and George W. Chrystal. New York, 1908.

Meyerson, A. "Van Gogh and the School of Pont Aven." *Konsthistorick Tidskrift* 3, no. 4 (1946): 56ff.

Mitterand, Henri. "Inscriptions du temps et de l'espace dans *L'Oeuvre.*" In *Emile Zola and the Arts: Centennial of the Publication of L'Oeuvre.* Edited by Jean-Max Guieu and Alison Hilton, Washington, D.C., 1988.

Moffett, Charles S. *The New Painting—Impressionism: 1874–1886.* San Francisco, 1986.

Moore, George. *Modern Painting.* London, 1893.

Muther, Richard. *The History of Modern Painting.* 3 vols. New York, 1896.

Newton, Joy. "Emile Zola and the French Impressionist Novel." *L'Esprit créateur* 13, no. 4 (Winter 1973): 320–28.

Niess, Robert J. *Zola, Cézanne, and Manet.* Ann Arbor, Mich., 1968.

Novotny, Fritz. *Painting and Sculpture in Europe, 1780–1880.* Pelican History of Art Series. Baltimore, 1960.

Pasco, Allan H. "The Failure of *L'Oeuvre.*" *L'Esprit créateur* 11, no. 4 (Winter 1971): 45–55.

Pickvance, Ronald. *Van Gogh and Arles.* New York, 1984.

———. *Van Gogh in Saint-Rémy and Auvers.* New York, 1986.

Pissarro, L. R., and L. Venturi. *Camille Pissaro, son art, son oeuvre.* 2 vols. Paris, 1939.

Reff, Theodore. *Manet and Modern Paris.* Washington, D.C., 1982.

———. "On 'Manet's Sources.' " *Artforum* 8, no. 1 (September 1969): 40–48.

Rewald, John. *The History of Impressionism.* 1946. 3d rev. ed. New York, 1961.

———, and Frances Weitzenhoffer, eds. *Aspects of Monet: A Symposium on the Artist's Life and Times.* New York, 1984.

Ripoll, Roger. *Réalité et mythe chez Zola.* Lille: Atelier réproduction des thèses, Université de Lille III, vol. 2. Paris, 1981.

Rookmaker, H. R. *Synthetist Art Theories—The Genesis and Nature of the Ideas on Art of Gaugin and His Circle.* Amsterdam, 1959.

Roskill, Mark. *Van Gogh, Gauguin, and the Impressionist Circle.* Greenwich, Conn., 1970.

Schuré, Edouard. *Le Drame Musical.* 1876. 2 vols. Paris, 1886.

Seiberling, Grace. "The Evolution of an Impressionist." In *Paintings by Monet,* 19–40. Chicago, 1975.

———. *Monet in London.* Atlanta, Ga., 1988.

———. *Monet's Series*. New York, 1981.

Seitz, William C. *Claude Monet—Seasons and Moments*. New York, 1960.

Shattuck, Robert. "Approaching the Abyss: Monet's Era." *Artforum* 20, no. 7 (March 1982): 35–42.

Shaw, [George] Bernard. *Shaw's Music: The Complete Musical Criticism in Three Volumes*. 3 vols. Edited by Dan H. Laurence. 2d rev. ed. London, 1981.

Shiff, Richard. *Cézanne and the End of Impressionism—A Study of the Theory, Technique and Critical Evaluation of Modern Art*. Chicago, 1984.

———. "The End of Impressionism." In *The New Painting—Impressionism: 1874–1886,* by Charles S. Moffett, 61–89. San Francisco, 1986.

———. "Impressionist Criticism, Impressionist Color and Cézanne." Ph.D. dissertation, Yale University, 1973.

Silège, Henri. *Bibliographie wagnérienne française*. Paris, 1902.

Suckale, Robert. *Claude Monet, Die Kathedralen von Rouen*. Munich and Zurich, 1981.

Tucker, Paul Hayes. *Monet at Argenteuil*. New Haven, Conn., 1982.

———. *Monet in the '90s—The Series Paintings*. New Haven, Conn., and London, 1989.

Van Gogh, Vincent. *The Complete Letters of Vincent Van Gogh*. 3 vols. Introduction by V. W. Van Gogh and Preface by J. Van Gogh-Bonger. Greenwich, Conn., 1958.

Venturi, Lionello. *Les Archives de l'Impressionisme*. 2 vols. Paris and New York, 1939.

———. *Cézanne, son art, son oeuvre*. 2 vols. Paris, 1936.

———. *Impressionists and Symbolists*. Translated by Francis Steegmuller. New York and London, 1950.

Wagner, Cosima. *Cosima Wagner's Diaries*. 2 vols. Edited and annotated by Martin Gregor-Dillin and Dietrich Mack. Translated by Geoffrey Skelton. New York and London, 1977.

Wagner, Richard. *My Life*. 2 vols. [No translator given.] New York, 1911.

Wölfflin, Heinrich. *Classic Art—An Introduction to the Italian Renaissance*. 1898. Translated by Peter and Linda Murray. London and New York, 1953.

Wooley, Grange. *Richard Wagner et le symbolisme français: Les rapports principaux entre le wagnérisme et l'évolution de l'idée symboliste*. Paris, 1931.

Ziegler, J. E. *Sculpture of Compassion*. Brussels and Rome, 1992.

Zola, Emile. "Deux expositions d'art au mois de mai." *Le Messenger d'Europe* [St. Petersburg]. June, 1876.

———. *Mes Haines*. 1883. Paris, 1928.

———. *L'Oeuvre* (The Masterpiece). 1886. Translated by Thomas Walton. Ann Arbor, Mich., 1968.

Index